IMAGES
of America

BEDFORD TOWNSHIP

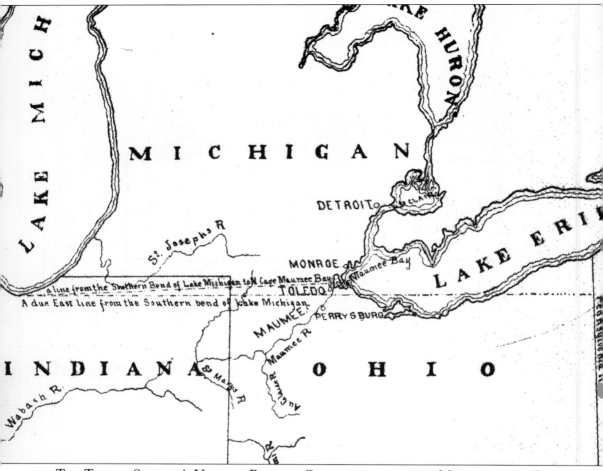

THE TOLEDO STRIP—A NARROW BONE OF CONTENTION BETWEEN MICHIGAN AND OHIO.
This survey map by David H. Burr indicates the area of dispute between Michigan and Ohio over the 484 square mile area known as "the Toledo Strip." Ambiguous wording of the Northwest Ordinance of 1787 and inaccurately drawn maps of the time simply compounded the problem. Earlier surveys, depending on the surveyor, favored either Michigan or Ohio. Both wanted control of the mouth of the Maumee River because of its potential as a major seaport, promising trade and commerce. Until this bitter dispute over the Toledo Strip was settled, Congress refused to grant Michigan statehood. Politics and egos took over and brought the dispute to a head with the Toledo War of 1835. See page 99 for the rest of the story.

IMAGES
of America

BEDFORD TOWNSHIP

Trudy Wieske Urbani

Published by Arcadia Publishing
Charleston SC, Chicago IL, Portsmouth NH, San Francisco CA

Printed in Great Britain

Library of Congress Catalog Card Number: 2005928475

For all general information contact Arcadia Publishing at:
Telephone 843-853-2070
Fax 843-853-0044
E-mail sales@arcadiapublishing.com
For customer service and orders:
Toll-Free 1-888-313-2665

Visit us on the internet at http://www.arcadiapublishing.com

*To all the dear souls who have allowed me to touch their lives
and preserve their memories for future generations: thank you!*

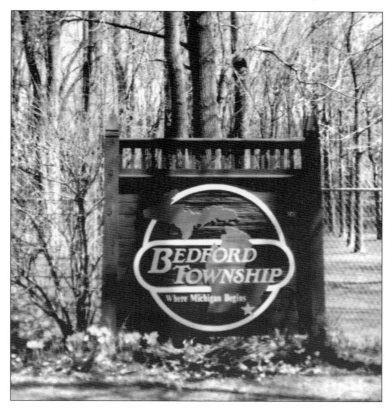

"**BEDFORD TOWNSHIP, WHERE MICHIGAN BEGINS.**" Toledo's largest suburb is the garden spot of Monroe County in southeastern Michigan. Five public parks are located in Bedford Township, and orchards, greenhouses, and nurseries dot the area.

CONTENTS

ACKNOWLEDGMENTS

I am grateful to every person who loaned materials or gave his time or talent to enhance the success of this project. Special thanks go to my "Good Samarians," who these past nine years have fanned the flames of interest in preserving our local history. I am also grateful to the people at the Bedford Township Hall, Bedford Senior Citizens Center, Monroe County Historical Museum, Monroe County Library System (particularly the Bedford branch), and the Historical Society of Bedford. Finally, I want to thank my patient husband, Aldo, for living in a house filled with boxes of history covering every flat surface. His encouragement—and his culinary skill—helped sustain this project through its duration.

All photographs used in this publication are from the computer archives and history files of Trudy Urbani, Bedford Township historian. Collected over a period of 10 years from cooperative residents and former residents of Bedford Township, they were loaned specifically for copying or scanning in order to preserve them for future generations at the Bedford Branch Library. If your photograph was one we used in this particular Bedford Township book, we thank you for sharing. If you have historic images, news articles, or school memorabilia from this area, please gather them up and let us hear from you. We are striving to preserve your past for future generations.

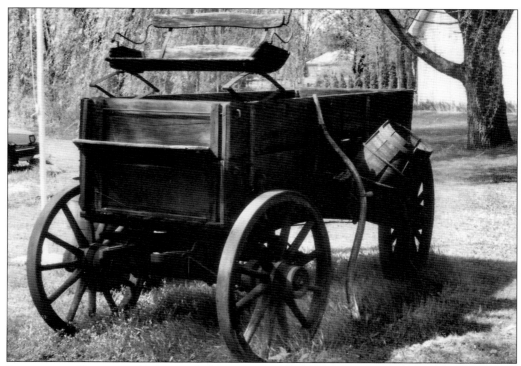

JOURNEY TO BEDFORD. Some traveled in wagons pulled by teams of oxen or horses. Some came via the Erie Canal. A few hardy souls got off the boat in New York and walked West. This book will tell you a little about these pioneering individuals.

INTRODUCTION

Bedford Township is located in southeastern Monroe County, Michigan. With about 60 families in 1836, today the township is home to over 30,000 people. Bedford covers an area of 39 square miles, and includes the three unincorporated villages of Lambertville, Samaria, and Temperance. Previously Bedford Township was known simply as West Erie (being a portion of Erie Township, formed in 1827). It was officially designated Bedford Township on May 2, 1836, before Michigan was admitted to the Union as the 26th state on June 27, 1837. As early as 1833, a West Erie post office operated in the home of William Dunbar, the first postmaster. Originally he lived near the Phelps cabin on the old American Indian trail, referred to on the 1876 map as Lambertville Road and now called Summerfield Road.

Postmaster William Dunbar had a long career and also served the people of the area as the first township supervisor, after Bedford Township was born. Lambertville was named for John Lambert, who had obtained 160 acres of land from the government in the early 1830s. Lambert was a man of considerable wealth and acquired extensive property in this area. In 1844, he deeded land to the township for a "Meeting Place and Burial Ground" on Monroe Road between Summerfield and Secor Roads, across from the first Lambertville Schoolhouse. A Methodist church was established there, and the town grew around it.

In 1863, a mail coach drawn by four matched horses followed the rutted dirt of Sterns Road to Monroe Road, then continued northeast toward Monroe. It delivered mail once a week, and people came from far and wide to Lambertville to collect their mail. Between 1873 and 1882, mail came through on the railroad at Sylvania and was delivered by mail coach to Lambertville twice a week. Deliveries were three times a week from mid-1880 through mid-1890, when daily deliveries took effect. Eventually the stagecoach was replaced with the train. The village of Lambertville was finally platted in 1888.

When the post office moved up Summerfield Road to the Lambertville area, it was housed in a store; the draw of the post office meant opportunity for business. Jacob Beitzel, the second postmaster, also made cigars, which he took to Toledo twice a week, bringing back the mail. Lambertville soon had several stores, a mill, blacksmith shops, wagon works, a slaughterhouse, and two undertakers—members of the pioneer families Janney and Farnham.

The population of Bedford Township grew, and a second post office was added near Little Lake, the only large body of water in the township. This post office was located at Erie Road between Lewis Avenue and Jackman Road from 1873 through 1878.

A petition was signed by 79 residents in the newly named village of Samaria about 1878, to move the post office to their more populated area. Samaria was named for Sam Weeks and Mary Mason, a popular couple who ran the local singing school. It had previously been called Weeksville after Sam's father, Elijah Weeks, who owned the first store, from which he operated the express office and telegraph. Weeks's store was in a prime location—alongside the Ann Arbor railroad tracks on the southeast side of Samaria Road. Prior Samaria Road had been known as M151, and also Lakeside, since it extended all the way to Lake Erie.

Samaria's oak and black walnut aided the growth of a lumbering community. Locating mills and other business in close proximity to the railroad allowed lumber and locally grown produce to be shipped afar. The settlement, which had started with only about six widely scattered farm families in the 1840s, thus became a thriving farm community. In the area of Samaria Road and North Street was a large lumber mill, a wagon works, and a cooper, or barrel maker. Roger Willard, who owned a store and large meeting hall, arranged to have his land platted in 1884 as the village of Samaria. There were only 14 lots in the tiny unincorporated village. Willard's

Hall later became a cheese factory, then a meeting place for the Lady Maccabees and a variety of other organizations. The hall was owned and operated for over 70 years as the Samaria Grange Hall. The building still stands at the corner of Samaria Road and Porter Street.

Samaria prospered and grew, but the establishment of a bank in Temperance at the end of the 19th century drew business away from Samaria. The population of the Samaria area has remained around 400. Today the quiet town boasts an exceptional park and community center, and recently has attracted younger settlers, who find this area a great place to raise their children.

Another good place to raise a family is Temperance, previously called Bedford Center. Due to the advent of the Ann Arbor Railroad around 1878 and lobbying by local landowner Lewis Ansted and his wife, Marietta, the name of the town was changed to Temperance. Staunch prohibitionists, the Ansteds went so far as to insert a clause in some of their property transactions, stating that "no liquor could be manufactured or sold on the premises." Lewis Ansted was appointed Temperance postmaster in 1884; his store, which also housed the first library, was located at the corner of Lewis Avenue and Main Street, now Temperance Road. The village was platted in 1895, and Sam Wallace opened the first bank in 1904. Once in operation, stores and businesses grew rapidly. Temperance soon had two churches, a mill, a dairy, several stores, and a hotel.

Currently these areas are experiencing revitalization, but the past is preserved in the Local History Room of the Bedford branch of the Monroe County Library System.

One

PIONEERS

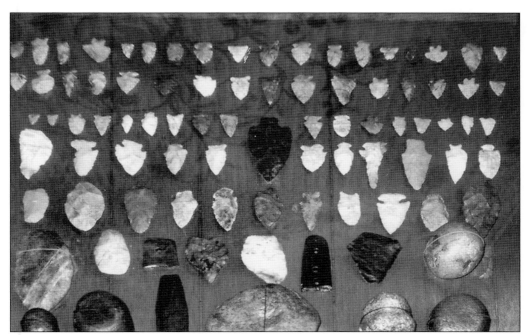

NATIVE AMERICANS WERE THE FIRST PIONEERS OF BEDFORD. Both the Silas Smith and Theophilus Osgood family traditions tell tales of Native Americans having cleared and planted crops on their land. Esther LaVoy Templin related stories of her great-grandmother, a Native American named White Feather, who was raised as a Potawatomi. Also there was a Kikapoo settlement of several hundred near the Morin Pointe area, which had been their hunting, trapping, and fishing grounds. Arrowheads, hand axes, and grinding tools were found all over Bedford Township.

JOHN BENJAMIN SULIER (1830–1890) AND CATHERINE (SULIER) LAPOINTE (1836–?).
Benjamin Sulier (1803–?) was the first French settler in what would become Bedford Township. He and his wife, Marie (1807–1880), arrived from Canada and settled in Erie Township, but were flooded out once too often, so they moved west. The 1839 assessment rolls indicate Benjamin owned 160 acres in Bedford Township, Sections 35 and 36. He grew wheat, corn, clover, and hay and kept a dairy cow, pigs, and chickens. He also worked as highway commissioner for two years. Benjamin and Maria raised seven children, including John Benjamin and Catherine. Today this sesquicentennial farm, pictured below, produces grains and soybeans for markets around the world and is still owned by Sulier descendants.

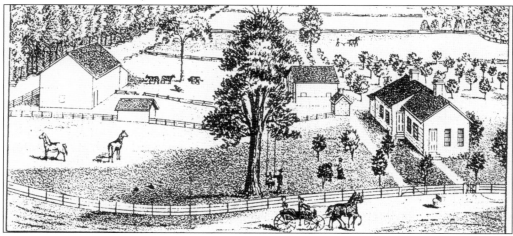

SMITH HOMESTEAD, MICHIGAN-OHIO LINE. In 1832, the Silas and Julia (Savage) Smith family settled on 160 acres in Section 33 of what would be Bedford Township. Crops were planted in 1833 on land the American Indians had cleared. In 1836, Silas dammed Halfway Creek for the area's first water-powered sawmill. After the Toledo War, which settled the border dispute, the home of Silas and Julia was bisected by the Michigan-Ohio line. This made for an interesting time when babies were born; depending on the birthing room, they were either Ohioans or Michiganders. The 1839 assessment rolls show that Silas Smith also acquired 130 acres in Section 4 T9S.

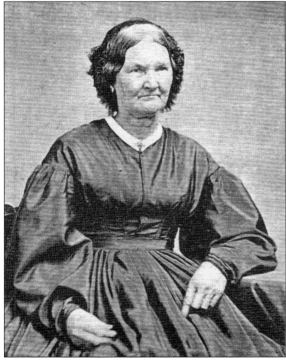

JULIA (SAVAGE) SMITH (1803–1875). Julia was the matriarch of the Smith family after Silas left for the gold fields in 1851, never to return. She suffered the loss of several children and struggled to keep the farm productive, though she managed well, and the property stayed in the family for over 150 years.

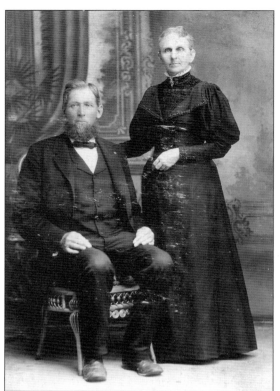

WEDDING OF OBED AND ALICE SMITH, SEPTEMBER 1868. Silas's son Obed operated the first steam sawmill in the area. Obed's son Fred carried on the tradition, followed by Harold, the last to farm the land. The Smith farm, designated a centennial farm, has been in the same family for more than 150 years. Over time, the huge farm has been sold off and a large part is now a golf course. The two homes left on the land have been sold. Only about two acres of the original Smith farm remain.

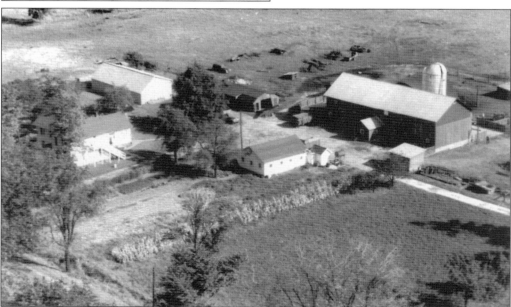

FRED SMITH CENTENNIAL FARM, 1859 SMITH ROAD. Fred Smith and Anna Smith (née Scharer) were the parents of Harold, who married Ruby Culver, and Ortha, who married baseball personality LeRoy "Bud" Parmelee. Most of their descendants still live in the area and take part in annual reunions. The 100th annual Smith reunion will be held in 2007.

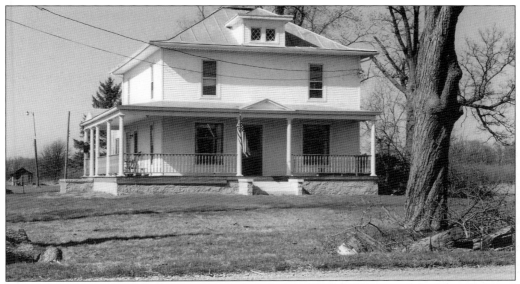

WHERE BEDFORD TOWNSHIP WAS BORN. Levi Lewis (1809–1891) came from New York and first acquired land around 1831. By 1839, he had 160 acres in Bedford Township Section 2. He married Elsy Experience Ketcham and fathered Walter, James, and Anna, who married Joel Hubbard. Some of their descendants are Osborn, Blouch, Weeks, Jackman, Whiting, Osgood, Cousino, Dusseau, Hachman, and Mc Clain. Bedford Township was born at 166 Samaria Road (formerly Lakeside) when the first official election was held in 1836. Levi was elected school commissioner. At that time, only about 60 people resided in Bedford Township. This home was built in 1905 by Charles Hubbard.

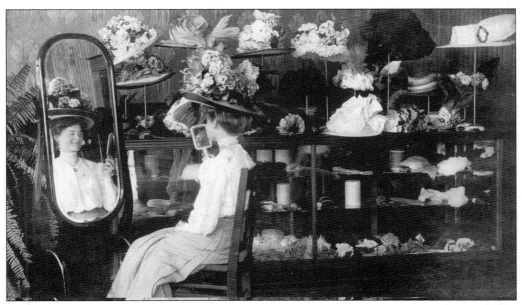

FLORENCE MC CLAIN HUBBARD SELECTS AN EASTER BONNET. In this photograph provided by Elizabeth (Hubbard) Mallory, Florence chooses the style of her late-19th-century hat. A young lady could pile on as many decorations as she liked from the vast selection of ribbon or feather trims.

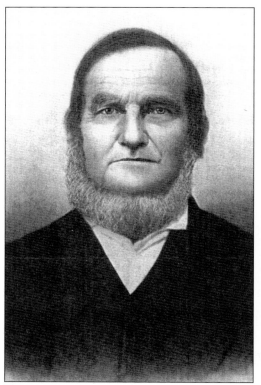

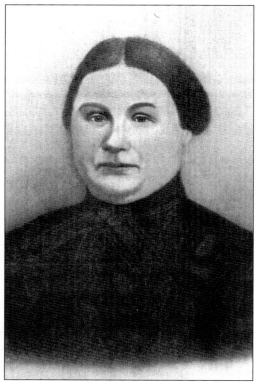

THEOPHILUS OSGOOD (1808–1883).

ROXANNA (BRIGHTMAN) OSGOOD (1809–1868).

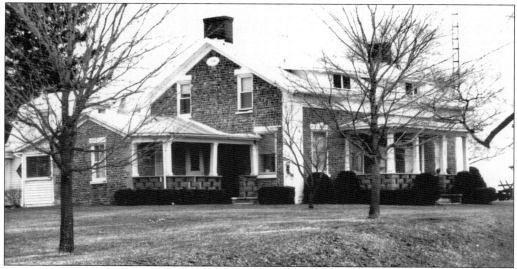

OSGOOD HOME, 744 SAMARIA ROAD. Theophilus Osgood married Roxanna Brightman in New York in October 1827 and moved to the Bedford area around 1833, settling on 160 acres in Section 1. First a cabin was built, and later a cobblestone home typical of those found in New York. The couple had 10 children. Theophilus was elected Bedford Township clerk in 1836. The property, certified as a centennial farm in 1950, is still family owned.

WILLIAM DUNBAR. In 1833, William Dunbar owned about 96 acres of land in Section 19 and more in Section 31. He married Mercy Aldrich, daughter of Mary Polly McLouth and Edward Aldrich. William served as the first postmaster and the first Bedford Township supervisor. From a log home (also the post office) on Summerfield Road in the area called Fortuna, he moved up to Lambertville to serve as postmaster there. By 1839, his Bedford Township property had grown to 160 acres in Sections 20 and 21. (Courtesy of *Wing's History of Monroe County*.)

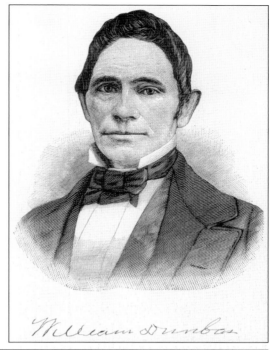

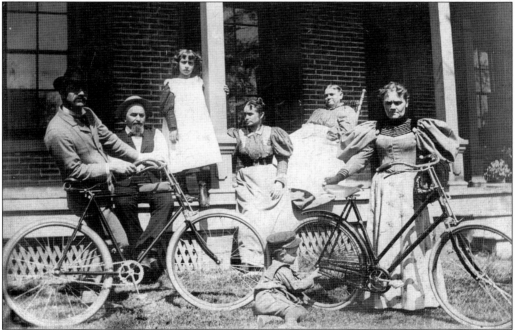

ADDISON DUNBAR (1835–1928) AND FAMILY ON THE FRONT PORCH. William Dunbar's son Addison (seated on left) worked at Monroe as probate court judge from 1889 to 1901. Addison's son William D. Dunbar was a teacher, store owner, and notary public who married Minnie Crippen (both are shown with bicycles) and lived in Samaria. They had seven children. The Dunbars later moved to Monroe to care for William's elderly parents, although he continued to do business in Samaria.

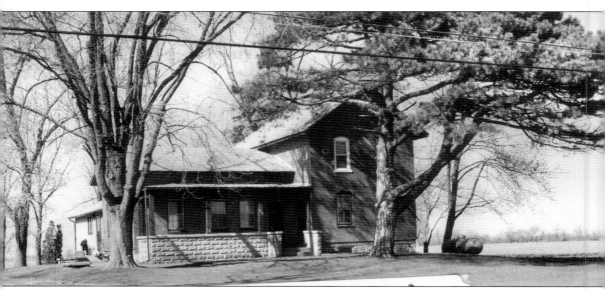

MASON MEN AND WOMEN ON SAMARIA ROAD NEAR LEWIS AVENUE. Henry Mason (1791–1878) of New York married Matilda Brightman and came to Michigan by wagon around 1835. They had five children. Henry built his log cabin in Bedford Township. Henry was a justice of the peace in 1836. In 1839, he was assessed for 80 acres in Section 2 and 120 acres in Section 20. Enjoying politics, he served one term in the Michigan State Legislature. Henry's son Chester D. Mason (1820–1865) married Emma Jane Butler in Monroe County in 1842, fathering nine children. Emma Jane was the daughter of pioneers Amos Butler and Rebecca Butler (née Vesey) who owned 120 acres in Section 1 of Bedford Township in 1839. The Butler lines connect with the Kinney, Salter, Smith, Osborn, Ford, Hitchcock, Pratt, and Williams descendents. Chester D. Mason owned property in Bedford Section 10 in 1859. Chester's daugther Laura married Cyrus Bradford, son of Stephen Bradford, the first elected commissioner of highways. Henry's son William H. Mason (1835–1922) purchased farmland in Bedford Section 2. He married Christina Klinck of Bedford and had eight children.

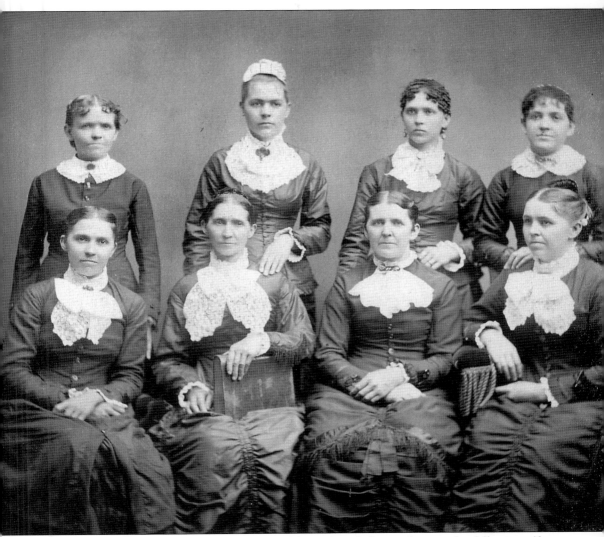

THE MASON WOMEN OF SAMARIA. Pictured here, from left to right, are the following: (first row) Ada Jane Mason (1854–1928), married to Michael Whiting; Emma Jane Butler (1825–1905), married to Chester D. Mason; Electa A. Mason (1842–1914), married to Roger Willard; and Emma E. Mason (1857–1932), married to John H. Hayward; (second row) Sarah R. Mason (1848–?), married to George Hayden; Laura W. Mason (1850–1888), married to Cyrus Bradford; Mary A. Mason (1861–1938), married to Samuel Weeks and then Emery Stowell; and Harriet D. Mason (1863–1956), married to Will Allen and then Clark Browning.

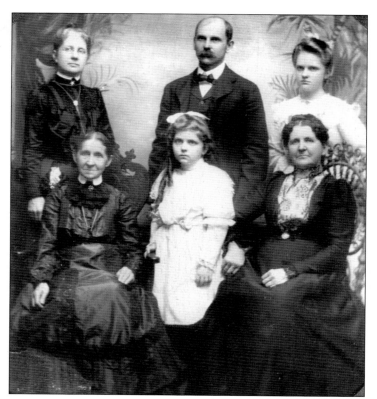

FOUR GENERATIONS OF THE MOYER FAMILY. Jacob Moyer married Mary Ann Shank in 1855 in LaSalle. Their son John A. married Jennie Willard in 1886. Shown here, from left to right, are the following: (sitting) Emma Mason (née Butler) and Electa Willard (née Mason); (standing) Jennie Moyer (née Willard); her husband, John; Florence; and young Jennie.

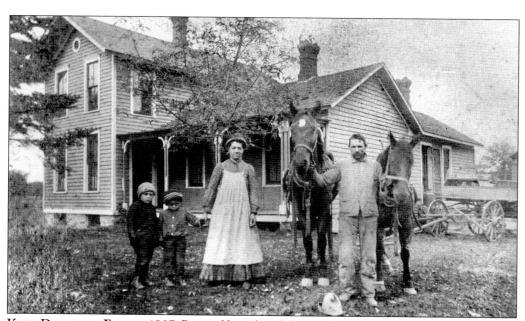

KARL DANZEISEN FAMILY, 1907. Pictured here from left to right, Albert, baby Carl, Anna (née Geisen), and Karl gather with their team of horses, vital to a farm of 57 acres. The house at 1250 West Temperance Road still stands.

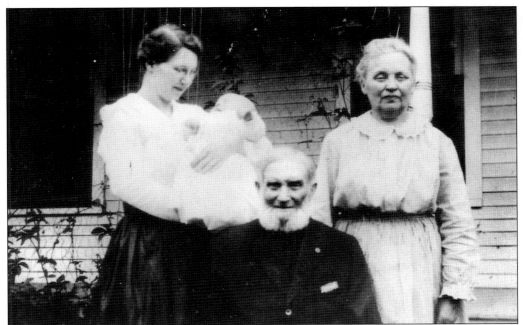

Four Generations on the Hungerford Property. Seated is Elon Galusha Hungerford (1834–1920), grandson of Josiah Hungerford Jr., who in 1859 owned property in Bedford Sections 3, 9, and 10. Elon G. married Catherine Jane Parks of Lambertville in 1859. Standing are Anne Lutz (née Bolton), holding son Arnold next to Elon's daughter Annie, born in 1862 in the original cabin and a teacher before she married Dan Bolton. Annie's siblings, Lida and Elon P., were born in this larger home and neither of them married. Around 1876, Elon G. Hungerford played a major role in the settlement of the Samaria area. His handwritten note on this Toledo, Ann Arbor and Northern Railroad document (seen below) dated January 1872 reads, "on the further condition that said company shall locate a side track and construct a station house on or near to the crossing of said railroad of the highway on the line between Section three and ten in the Township of Bedford, Monroe County, Michigan." Due to his $50 investment in the Ann Arbor Railroad, Samaria would have a depot and siding and the doors would open to commerce in the area.

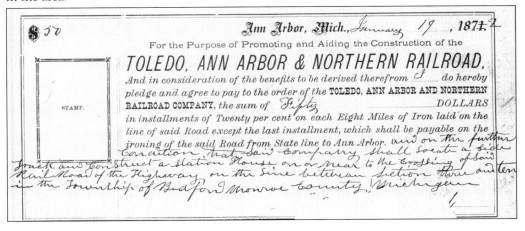

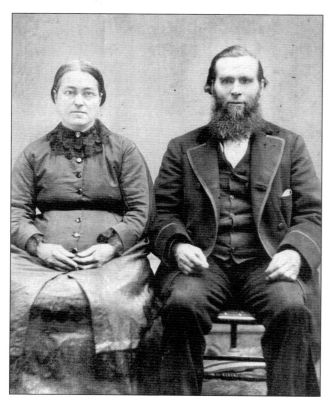

ELIJAH AND ELIZABETH WEEKS. Elijah Weeks (1826–1907) arrived from New York with relatives named Monnell and gradually accumulated about 200 acres in Section 10 of Bedford. He married Elizabeth Kirkland in 1851 and had eight children. He was the first store owner in the area known as Weeksville. In 1859, he advertised dealing in dry goods, groceries, and produce. He was also a farmer. About 1878, the area known as Weeksville was named Samaria in honor of Elijah's son Sam, who would be the first postmaster of the village, and Mary Mason Weeks, his bride, who ran the local singing school. Below is the modernized home of the Weeks family that changed hands in 1885 when Elijah traded 180 acres of Samaria property for 640 acres of Joseph and Hepzibah Johnston's property in Virginia.

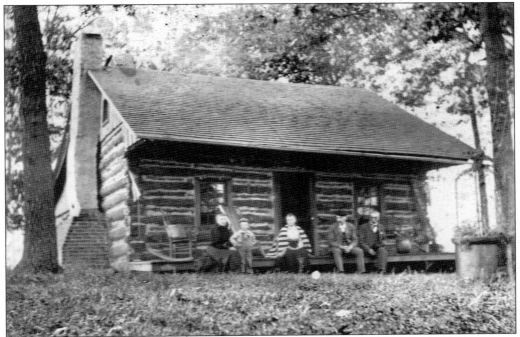

HOME TO MANY. Located on Secor Road, this 200-year-old residence was originally on the old Chittendon Dairy Farm and housed families such as the Powleslands, who raised several children there, as well as the Lennards and the Osborns. Henry Clay Osborn was born there in 1910. It has since been restored by Dean and Janine Vollmar.

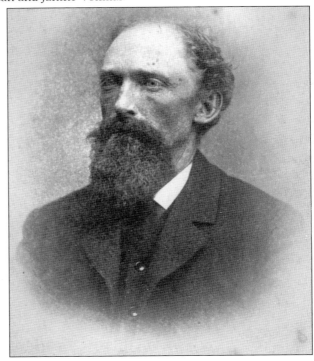

ROGER WILLARD. Roger Willard owned property in Section 2 of Bedford Township. He was a farmer who bred cattle, sheep, and swine, as well as fine horses. He purchased property in Section 3, the Samaria area, where he opened a store and public hall in 1853. His general store and post office was a popular spot in Samaria.

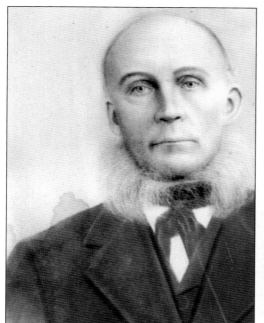
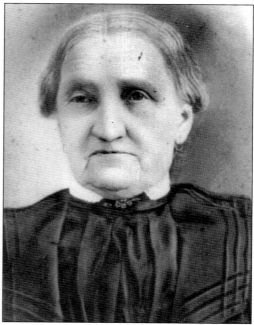

CHRISTOPH (1820–1893) AND SOPHIA E. EISENMANN (1826–1903). Pioneers in Bedford Section 3, the Eisenmanns' original red brick homestead still stands in Samaria.

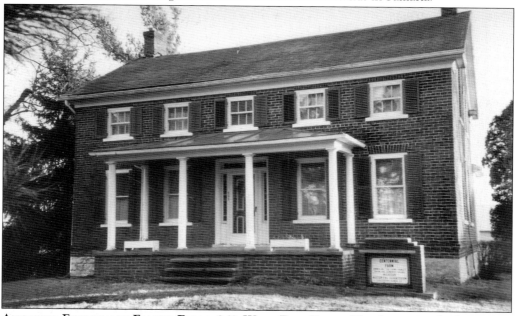

ANOTHER EISENMANN FAMILY FARM, 243 WEST ERIE ROAD. This house was built in 1858, and a barn on the property dates back further. Designated a centennial farm in 1962, today this 80-acre property is owned by Gene and Darlene Eisenmann, descendants of George Jacob Eisenmann, who married Dora Willard in 1887. George's sister Karolina married John Henry Rooh in 1874, and their son Chris was a teacher at the old Stone School on Crabb Road. Chris Rooh's Crabb Road farm was also designated a centennial farm.

Scott-Dodds Centennial Farm, Jackman Road near Erie Road. This 55 acres was originally part of the Levi Lewis property and was later owned by Christopher Scott. Christopher's daughter Martha married William Dodds. Their son Ellis William Dodds married Elise Gess. Elise reports that there was once an American Indian encampment on the Dodds property.

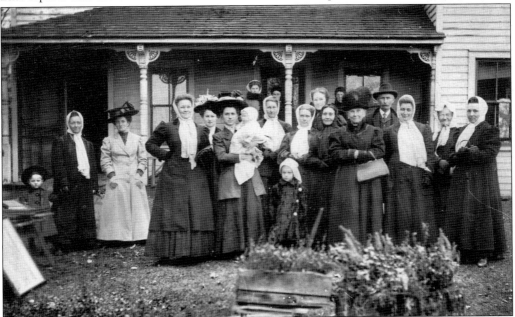

Original Aaron VanWormer Homestead. The 7315 Jackman property, at Sterns Road in the area known as Liberty Corners, was the site of Aaron VanWormer's moving sale about 1910, which drew an impressive crowd even in the cold of winter. In attendance were representatives of several pioneer families of the area such as Mock, Pickard, Straus, Bibb, Aysh, Gilchrist, and Milloy. The homestead would later be owned by the Robert Lowe family.

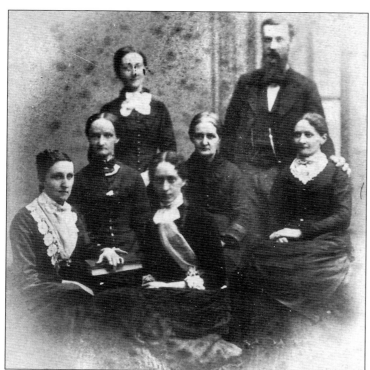

HUBBELL FAMILY.
William P. Hubbell was assessed for 80 acres in Bedford Section 1 in 1839. He married Mary Willard, daughter of William Willard and Mary Willard (née Larkin), in Lasalle, Monroe County, in 1834. They had 10 children; their son S. M. Hubbell, born in Bedford in 1837, attended the old log schoolhouse at Mason's Corners. He became a reverend in later years. Their oldest daughter, Urania Hubbell, would marry William S. Tuttle.

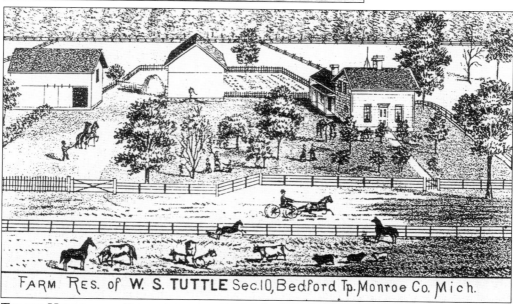

TUTTLE HOMESTEAD, BEERS ATLAS OF 1876. John Marshall Tuttle bought 40 acres in Section 10 in 1835. He and his wife, Rhoda, had eight children. Their son William S. Tuttle (1826–1879) married Urania Hubbell in 1854 and had seven children. Their son John married Etna Vaughn and had five children. John and Etna's daughter Alice would later marry a Newcombe. William S. Tuttle served as the second postmaster in Bedford Township, and his family lived on Erie Road in the area called Little Lake.

AYSH CENTENNIAL HOME, JACKMAN ROAD. John Aysh Sr. (1790–1878) purchased 80 acres of land in Section 34 of Bedford when it was still the Michigan Territory in 1834. In 1849, he married Ann Brooks in Lambertville and had nine children. The family homestead, shown above, was located at 1766 Jackman Road near Smith and was certified as a centennial farm in 1951. Their daughter Ann married Englishman John Newcombe and bore 11 children. John Aysh Jr. was a farmer and former carpenter who settled in Section 33 and married Ann Jackman in 1859. His older brother William married Catherine Crowell and owned 140 acres of farmland in Bedford, including an apiary. William had extensive property in England and crossed the Atlantic seven times to check on it. Below is the homestead of John Newcombe and Ann Newcombe (née Aysh) at 1522 Sterns Road in Section 27 in Bedford Township.

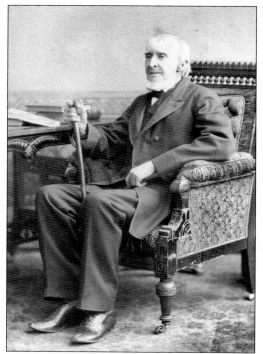

LUCAS ADAMS (1806–1895).
MARY E. (BAKER) ADAMS (1812–1891).

ADAMS SESQUICENTENNIAL HOMESTEAD. Lucas Adams, above left, and Mary Adams (née Baker), above right, came from Vermont and purchased 120 acres in Section 22 around 1833. He was a farmer, raising Durham cattle and Cotswold sheep. This farm has been in the Adams family for over 150 years and is located on Dean Road in Temperance. The Adamses' son J. Q. was assessed for 80 acres in Section 2 and 81.54 acres in Section 3 in 1839. He married Jane Newcombe in 1870. (Courtesy of Don Adams.)

LAMBERT PROPERTY, 8151 SUMMERFIELD ROAD. English born John Lambert (1770–1857) married Mary Polly McLouth (1789–1854), the widow of Edward Alrdrich and mother of two girls, around 1823. They had two children, Lewis and Elizabeth. John obtained 160 acres from the government in 1833, acquiring land in Sections 19, 29, 30, and 32. In 1836, he was elected the Bedford Township school commissioner and director of the poor. In 1844, he donated one-and-one-third acres in Section 19 to Bedford Township for a "meeting place and burial ground," and the area became known as Lambertville. In 1853, John sold his farm and moved to Toledo. Polly died of cholera at the Monroe home of her daughter Mercy Dunbar (née Aldrich). Both are buried in Lambertville Cemetery. This building at 8151 Summerfield is historic. It was once Gilman's Tavern with an upstairs dance hall. Lambertville's second postmaster, Jacob Bietzel, had a tobacco business here. Twice a week he took his cigars to Toledo, returning with the mail. J. J. Sumner had owned this and the corner store in 1876. This double occupancy home was owned by Jacob Slick in the late 1800s. Lambertville's only woman doctor, Ada F. Slick, treated patients here. Current owner, Marlene Himburg Sterling, is attempting an historic restoration.

HOWENSTINE MEN. The men, from left to right, are as follows: (first row) Jacob and David; (second row) Frank, W. Henry, and J. Wesley. The Jacob Howenstine and Nancy Howenstine (née Jackson) homestead was located on Consear, east of Secor and consisted of 80 acres in 1868. The Howenstines moved here from Wayne County, Ohio. They had cows and chickens for their butter, egg, and cheese business. Their family of 12 children would grow through marriage to include Young, Knepper, Saxton, Thornton, and Klump lines.

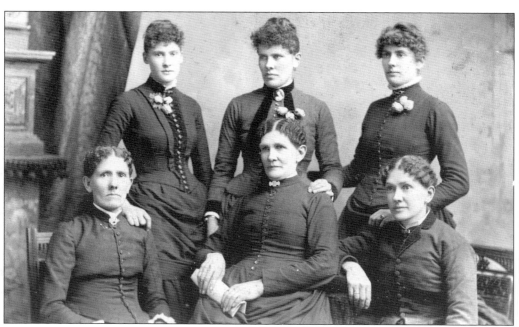

HOWENSTINE WOMEN. The women, from left to right, are as follows: (first row) Sarah Jane, Nancy, and Rachel; (second row) Lucy Ann, Emma, and Mary.

THORNTON HOMESTEAD, SUMMERFIELD ROAD. Ebenezer Thornton of Lambertville was elected a commissioner of highways and "fence viewer" at the first Bedford Township election in 1836. By 1839, Ebenezer owned 237 acres in Section 19, 140 acres in Section 30, and 160 acres in Section 24. The son of Michael Thornton and Thankful Thornton (née Jewell), he married Abigail Wood and they had eight children. Abigail died in 1836 and became the first to be buried in the new Lambertville Cemetery. Ebenezer and his second wife, Lucina McArthur-Hair, raised three more children.

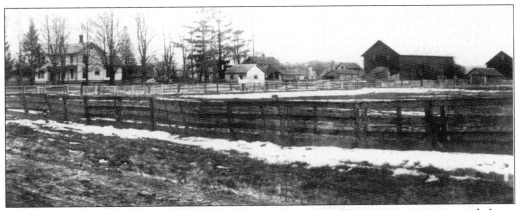

JACKMAN-POWLESLAND HOMESTEAD, 2925 SMITH ROAD. This property was passed down to the Brock family. William Brock owned land in Section 5 T9SR7E in 1834 and Section 6 T9SR7E in 1859. Brocks had started growing on Secor Road, but the settlement following the Toledo War put their property in Ohio. There the taxes were much higher, so they moved around the corner into Michigan on Smith Road, where the greenhouse has been ever since.

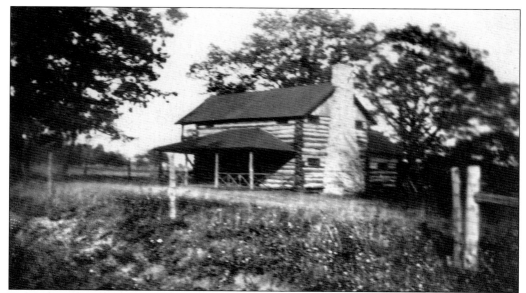

RASMUSSEN CABIN, SUMMERFIELD AND SECOR ROADS, LAMBERTVILLE. Jens Peters "Pete" Rasmussen, 1875–1944, and Molly Rasmussen (née Peterson, 1880–1943), wed in Denmark in 1905, came to the United States in 1906, and moved to Lambertville in 1917. The family had a large chicken ranch at this location.

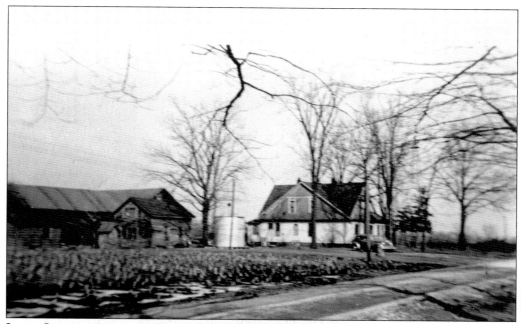

JAMES JOHNSON–ALBRING FARM, SECTION ROAD, LAMBERTVILLE. James Johnson purchased 40 acres of land in Section 31 around 1833. Assessment rolls for 1839 show a James H. Johnson owning 96 acres in Section 31 as well. The family homestead at 3494 Section Road was certified as a centennial farm in 1951. Members of the Albring family are the current owners. Their horse barn is said to be the oldest in all of Monroe County.

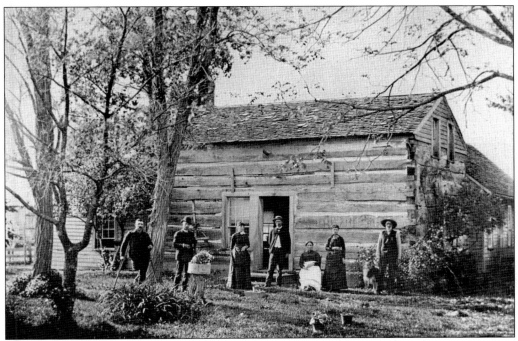

ORIGINAL VESEY CABIN, SECTION ROAD, 1892. Family members attending this reunion are the following, from left to right: (seated) Rosaland Vesey (née Trombly); (standing) Milton Vesey, William J. Vesey, Alice Vesey, Arthur Vesey, Alta Vesey, and their father, Edwin Vesey, with the family dog.

EDMUND RAWSON, BORN IN NEW YORK IN 1810. Edmund Rawson and his wife, Charlana Rawson (née Phillips), arrived in the Bedford area in 1833. Their daughter Emeline Rawson (1833–1887) married Robert S. Hitchcock, son of Elisha Hitchcock and Christina Hitchcock (née Spoor). After Edmund's wife passed away, he married Mary Doty, the widow of Farley McLouth. Rawson School, which has been in existence in this area since about 1835, is named for Edmund Rawson.

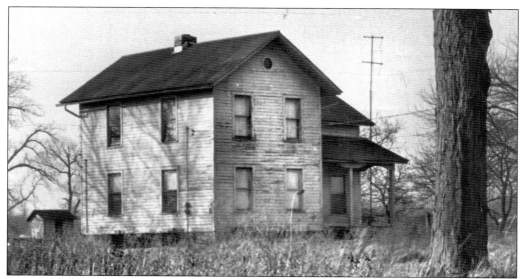

HITCHCOCK HOMES. Elisha B. Hitchcock Sr. (1794–1844) of New York settled here in 1833. He purchased 160 acres in Section 34 and 80 acres in Section 35. Elisha and Christina Hitchcock had 13 children, and the 4 youngest were born in Bedford Township. Elisha was elected as an assessor at the first Bedford Township election in 1836. Five Hitchcock families settled around Sterns and Lewis Avenues, where they plotted their own family cemetery. The area became known as Hitchcock's Corners. Omer C. Hitchcock was the listed owner at 7025 Lewis Avenue (above) when it was certified as a centennial farm in 1951. Emma Hitchcock (1857–1909) was born to Robert and Emmeline Hitchcock at 7333 Sterns Road (pictured below). Emma was a correspondent to the Monroe Commercial newspaper.

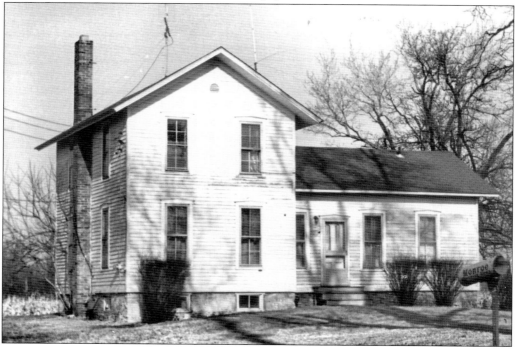

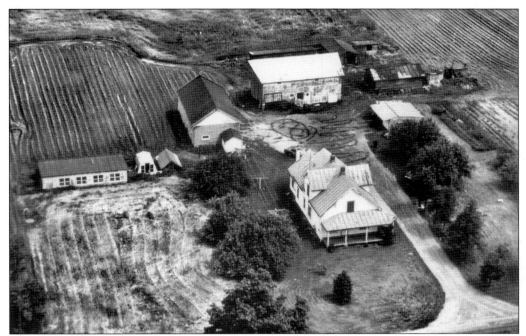

MAY FAMILY HOMESTEAD, STERNS AND JACKMAN ROADS. This property, at Sterns and Jackman Roads, was later owned by the Hoffman family, who also owned the slaughterhouse to the east. William J. May of Devonshire, England, purchased land here in 1831. In 1837, he married Helen E. Hitchcock, the daughter of pioneers Elisha and Christiana Hitchcock.

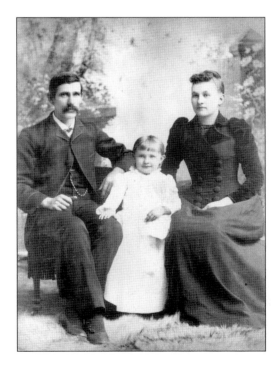

DAVID DULL AND CATHERINE DULL (NÉE CARR). Upton Carr was born in New York in 1817. Around 1839, he married Clarissa Ford and moved to Bedford, where he owned 40 acres each in Section 14 and 15. Their second son, George Carr, married Elizabeth Ansted. Their second son, George C. Carr, married Mabel Vaughn. Catherine E. Carr married David Dull in 1884 and had one girl, Florence. The Carr family lived at 9361 Lewis Avenue, generally considered the oldest house in Temperance. Milton S. Carr, Upton's great grandson, donated six acres for Carr's Grove in downtown Temperance.

THE JOHNSON HOME, MONROE ROAD. Across from the Methodist church, this property was known for its apple orchards. Today it is the home of a Hubbard descendant.

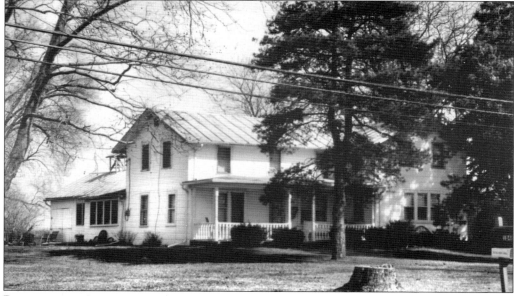

RICHARD AND MARY BIBB. The Bibbs emigrated from Wales and settled in New York first, then the Bedford area, on 120 acres in Section 28 around 1834. The homestead at 1848 Sterns Road was designated a centennial farm in 1951 and is the only structure remaining on the original Bibb property, which has just recently been developed into a subdivision. The property was owned by Roland Straus, a fifth-generation descendant of the Bibb family, which donated property for the Wesleyan Church at the corner of Sterns and Jackman Roads, in the area known as Liberty Corners.

LIBA ALLEN, 1802–1881, AND LAURA ALLEN (NÉE DOANE), 1806–1867. These pioneers owned property at Summerfield and Monroe in Lambertville in 1860. Their youngest daughter, Almeda, married Ellwood Janney and raised 10 children. One of their sons, Clarence, married Elsie Smith, daughter of Jasper Smith and Hattie Smith (née Kirkland), who bought the undertaking business from Lucius Farnham of Lambertville. The children of Ellwood and Almeda Janney are listed below.

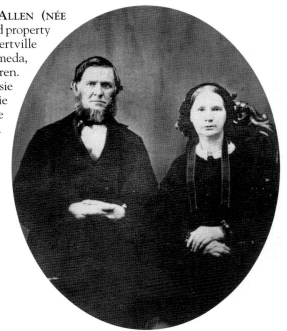

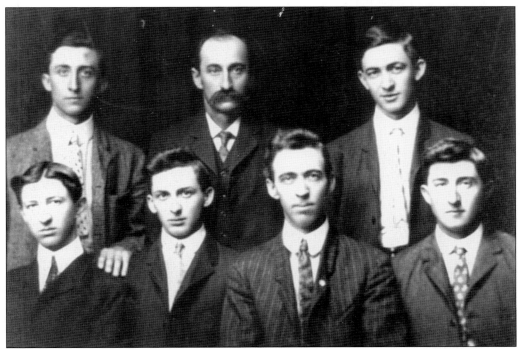

JANNEY BROTHERS. Pictured here, from left to right, are the following: (first row) Ralph Dare Janney, William Penn Janney, Leslie Emerson Janney, and Edward Allen Janney; (second row) Ray Sherman Janney, Clarence Ellwood Janney, and Charles Sumner Janney. Absent are the sisters, Cora Frances Janney, Laura Esther Janney, and Almeda May Janney, an acclaimed history professor at the University of Toledo.

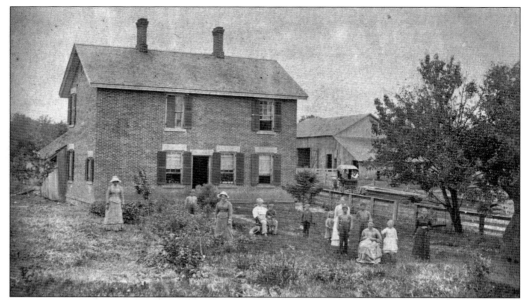

THE HOMESTEAD AND A PICKARD PORTRAIT. Anna Pickard (née Hoag) gave her husband five children before she died, and William's second wife, Sarah Pickard (née Smith), gave him 11 more. The land shown above was originally purchased in 1833 by Charles Dohm. Anna Pickard was one of six children of Jackson Hoag and Phoebe Hoag (née Brown) of New York, who had purchased 70 acres each in Sections 3 and 4 in July 1833. By 1839, Jackson Hoag also owned about 8 acres in Section 35, about 4 acres in Section 34, and a grand 640 acres—the entirety—in Section 22. Jackson Hoag was elected School Commissioner at the first Bedford Township election. The homestead, at 1507 Smith Road, was certified as a centennial farm in 1988. Below Sarah Pickard (née Smith, 1833–1899) stands in the middle of four of her grown children. Pictured, from left to right, are Alfred, Oliver, Sarah, Orin, and young Rhoda. William and Sarah Pickard are buried in Hitchcock Cemetery.

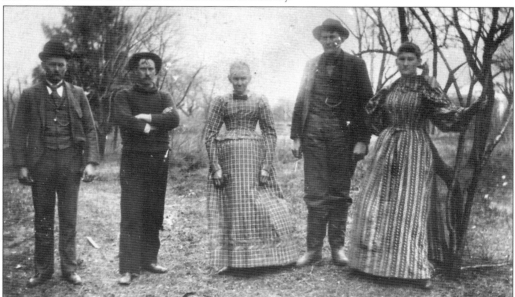

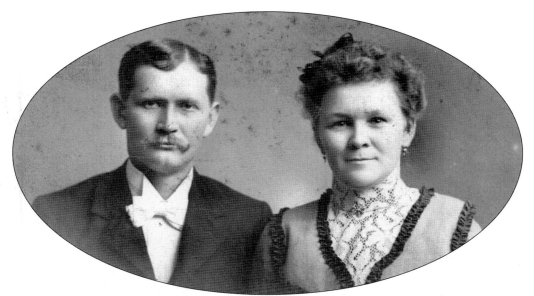

ALFRED J. PICKARD AND MARY PICKARD (NÉE NIEHAUS), MARRIED 1897. The Alfred Pickard family lived at 6232 Jackman Road in a large white farmhouse and ran a dairy farm. Alfred once received a silver berry spoon, awarded for the purest milk in the area. The couple's daughter Lasetta Pickard never married. She was a teacher and lived on the homestead all her life. The family farm is now part of the Bedford Hills Golf Course.

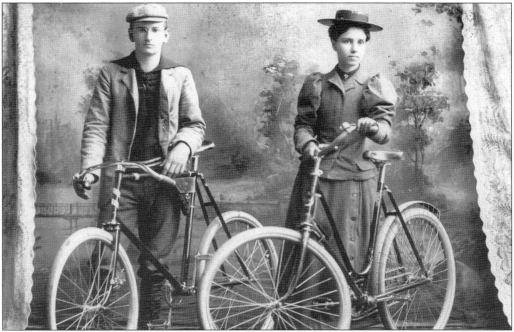

OLIVER PICKARD AND MARTHA PICKARD (NÉE HIMBURG). Oliver and Martha raised seven children in their West Toledo home. He worked for a bicycle company in downtown Toledo when bicycles cost over $100. Bicycles were important enough to be included in a formal studio portrait. It was also good advertising.

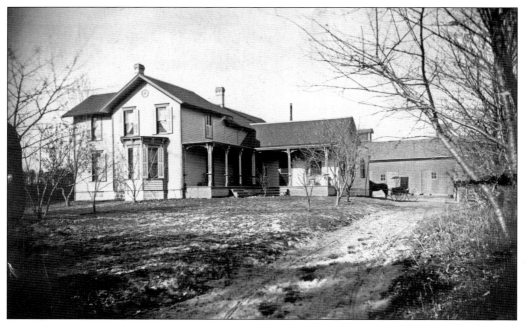

HOMESTEAD OF DAVID H. HOOVER AND MINNIE HOOVER (NÉE PICKARD). Minnie's untimely death in 1905 left four young children. The next year David married Catherine Roe, who had two more. The home was large enough for the expanded family. This farm began as a cattle ranch and ended up as a subdivision. The first home at 1246 Smith Road (seen here) burned in 1905. The second home still stands, though it is no longer in the Hoover family.

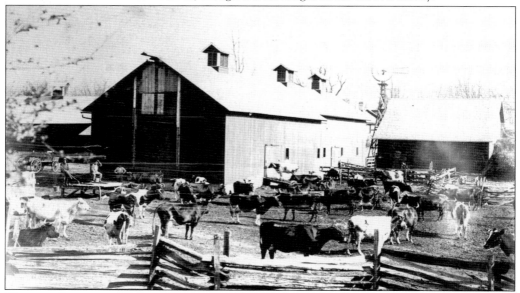

HOOVER STOCKYARD, 1894. Keith Hoover was very successful at raising pedigreed cattle, as evidenced by this photograph of prize winners. After World War I, he shipped his best bull over to Europe to help restock the herds in England, which had been devastated by the Blitzkrieg. Keith Hoover married Hazel Wagner in 1915 and they had one child, who died in infancy. The farm is now the Hazeldell Farms subdivision.

CHILDREN OF DAVID HOOVER AND MINNIE HOOVER (NÉE PICKARD). Pictured in 1898 are, from left to right, Keith C. Hoover (age 4), his baby brother Burr J. Hoover (age 2), and his sister Irma Gem Hoover (age 3). There were three more siblings in the family.

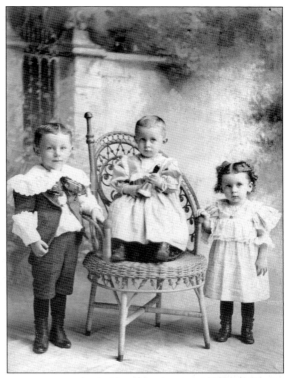

WILLIAM AND WEBSTER THORN. Here the Thorns feed chickens in the barnyard on their grandfather's Secor Road centennial farm. Daniel Webster Thorn (1837–1908) was a farmer from New York who dealt in grain and stock in Bedford Section 8. He was also the 1876 proprietor of a sawmill in Bedford Section 14. Daniel's brother Theodore Thorn married Mary Pierce and was a farmer in Bedford Section 27 in 1876. His son Mavor Thorn was the well-liked janitor at Liberty Corners School.

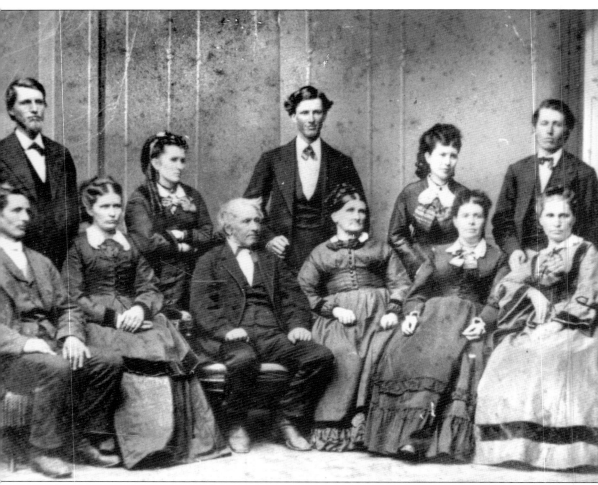

CURSON-SOUTHARD FAMILY. James Harding (1773–1853) and Ann Gotame Southard (1770–1849) emigrated to the United States from England around 1833. He was a shipbuilder. He purchased 800 acres of land (at $1.25 per acre) bordering on what are now Jackman, Lewis, Alexis, and Telegraph Roads in Toledo, Ohio. The Southards had 10 children: Ann, who married George Laskey in 1813; James H. Jr., who married Mary E. Ellis; Thomas, who wed three times (one wife was Grace Powlesland of Bedford); William, who married Sarah Grey Chambers; Elizabeth, who married George Bevins; Mary, who wed George Curson; Samuel, who married Charlotte Hitchcock of Bedford; Rhoda, who married George Dixon; Joseph, who married Margaret Kunkle; and Priscilla, who wed John Wilkinson, one of the earliest pioneers to the Bedford area who owned 65 acres in Bedford Section 2. The Southards had their own private cemetery on Alexis Road. George Curson (1803–1875) was here around 1834 in Section 33. He married Mary Southard before 1830 and had 10 children. Their farm was near Jackman and Smith Roads, where they raised collies.

WEDDING OF ADOLPH AND LYDIA (DESZELL) COUSINO, JUNE 6, 1903. Adolph (1878–1950) and Lydia (1881–1959) had nine children, who then married into the McQuade, King, Nusbaum, Nadeau, Morrin, Jacobs, Gleckler, and McClellan families. One also became a nun.

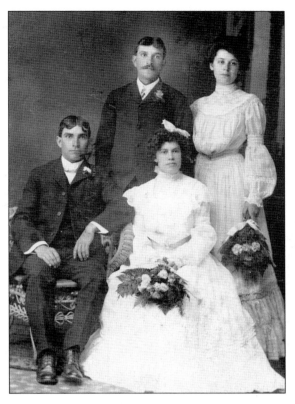

ADOLPH AND LYDIA COUSINO STAND BEFORE THE HOMESTEAD AT 8032 CRABB ROAD, TEMPERANCE, IN 1941. Originally Louis Basil Cousineau (Cousino) II, settled on Section 25 of Bedford Township and built a cabin on his 80 acres. A two-story home was built in 1925 to house their family of nine children. In the same family for over 180 years, the place was certified in 1990 as a sesquicentennial farm.

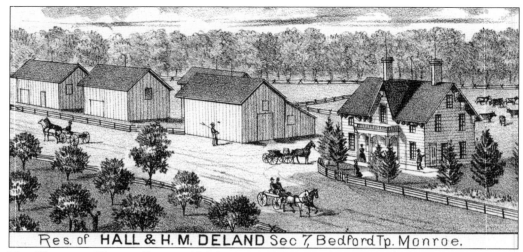

Res. of **HALL & H. M. DELAND** Sec 7, Bedford Tp. Monroe.

THE HALFWAY HOUSE, BEERS 1876 ATLAS OF MONROE COUNTY. Obediah Deland, elected school inspector at the first Bedford Township election in 1836, owned 80 acres in Section 20 and 120 acres in Section 21 by 1839. His grandson Hall Deland owned 57 acres in Bedford Section 7 and 44 acres in Section 12 in 1839. Hall Deland operated the Halfway House on Summerfield Road halfway between Dundee and Toledo Markets. A charter member of the Deland Wesleyan Church, Hall was a staunch abolitionist, and was rumored to have aided the Underground Railway.

THE BITTNER-BILLAU CENTENNIAL HOMESTEAD, SECTION ROAD. This property was originally owned by John Bittner, who married Mary Rohm around 1860 and had two children, Moses and Lydia. Lydia married Martin Billau in 1898. Their son Leo married Mildred Eff in 1924. Their two children were Kathryn, who never married, and Charles, who married Eleanor Klump in 1949. Charles and Eleanor raised Thomas, Christine, and Michael. Billaus have always gone to market in Toledo with their produce. Eleanor is the past president of the Toledo Farmers' Market.

THE NUSBAUM CENTENNIAL FARM AND HOMESTEAD, ERIE ROAD NEAR SECOR. Nicholas Nusbaum, born in 1823 in Wurtenburg, Germany, married Walberga Zerlanti, came to America, and purchased 40 acres in Bedford Township in the late 1800s. The couple then raised their five children, Martin, Mary, Nicholas, John, and Julia. These five married and raised large families, who also raised large families. There are now hundreds of their descendants in the area.

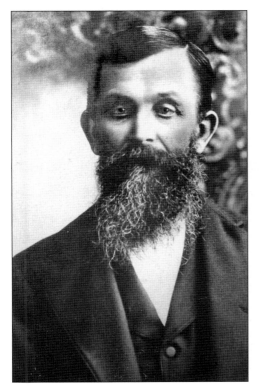

LEWIS ANSTED, FOUNDER OF TEMPERANCE. Jacob Ansted (1815–1864) brought his wife, Elizabeth (née Welker, 1818–1904), to America from Germany between 1824 and 1834. They travelled to Pennsylvania and on to Sandusky County, Ohio, where Jacob took up farming. Several children blessed this union. Jacob and Elizabeth traded for land in Bedford and headed north. Jacob caught malaria and died along the way, so the family turned back to bury him, then continued on. Elizabeth raised their family of 10 children in Bedford Section 22. Her son Lewis Ansted (born in 1846), a farmer in Section 14, married Marietta Hayden and became the founder and first postmaster of Temperance, Michigan. Marietta was a staunch Women's Christian Temperance Union advocate.

PHELPS HOMESTEAD AND OGDON CABIN, SUMMERFIELD ROAD, LAMBERTVILLE. Charles E. Phelps (born in 1810), a New York carpenter, settled on 40 acres in Section 33 in 1834. He and his wife, Charlotte, had seven children. After Charles's death in the late 1850s, 26 acres went to their son Stephen. About 1912, James and Ina Duley Ogdon purchased the home and added on an 1865 cabin. Its logs were numbered, disassembled, and moved from Ottawa Lake, then reassembled here. In an upper corner bedroom, Ina Duley Ogdon wrote the verse "Brighten the Corner Where You Are," which was popularized by revivalist Billy Sunday.

HOMESTEAD, STEARNS ROAD NEAR CRABB. Polly and Seneca Tillotson shared this property with Julius L. and Lavania Stearns, according to the 1850 Census. Two generations later, Henry Hamilton Sterns was Lord School District No. 6 director (from 1909 through 1914). His son Robert L. followed in his father's footsteps, serving as director from 1938 until 1941. By then, the name had been changed to Banner Oak School and the Stearns name had become Sterns.

Two

EARLY SCHOOLS, CHURCHES, AND CEMETERIES

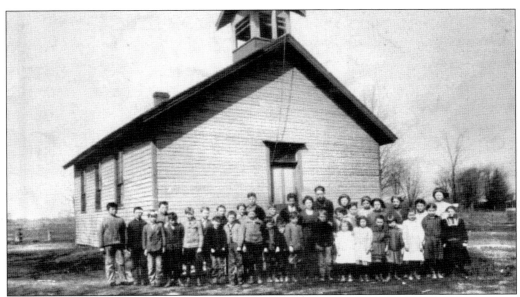

DISTRICT NO. 8, RAWSON SCHOOL. In 1835, the school was located near Sterns and Summerfield. It was then moved to Smith Road, between Douglas and Secor. Finally it was moved to Secor Road, near Section Road, on property owned by the White family. Remodeled considerably, the building has remained at the Secor site for many years. When the school closed about 1970, it was reopened as the first Bedford Cooperative Nursery.

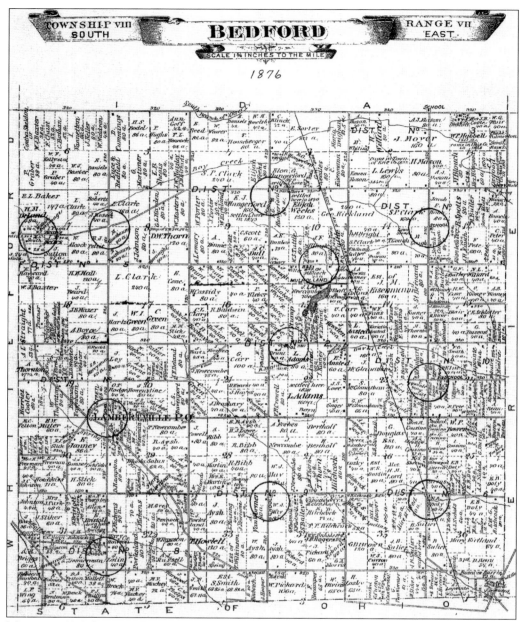

MAP OF 1876 SCHOOL DISTRICTS. School districts were generally two miles apart. District No. 5, the Little Lake Log School, was first built before 1855 on land owned by the Tuttle family on Erie Road between Lewis and Jackman Road. This tiny school served the community until it became overcrowded around 1865. It was closed and the students divided between Samaria and Temperance. No photograph of the building has been found as yet, but one can pinpoint its location on this map, along with the other rural schools.

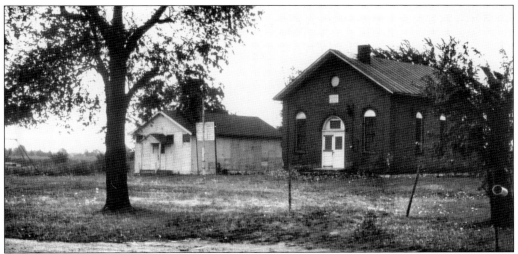

DISTRICT NO. 6, BANNER OAK, WAS ORIGINALLY NAMED LORD SCHOOL. Located on the north side of Sterns at Crabb Road since 1843, it was replaced in 1871 by a new red brick school across the road. Around 1930, Lord was changed to Banner Oak after a Civil War legend about a flag hung from a large oak tree. The prediction was that on whichever side the flag fell, that side would win the war. From 1930 to 1956, a wooden portable building was added. This later served as the Bedford YMCA and was destroyed in the 1970s as a volunteer fire department training exercise. The brick school closed in 1956 and would house a voting precinct, a Baptist Church, even briefly a little theater group. Eventually it was turned over to the Historical Society of Bedford, which, with the help of the alumni, restored it and worked to have it placed on the Michigan Register of Historic Sites. It is the only building in all of Bedford Township that holds this honor. Today Banner Oak School is a living history museum where classes come to reenact school days typical at the beginning of the 20th century.

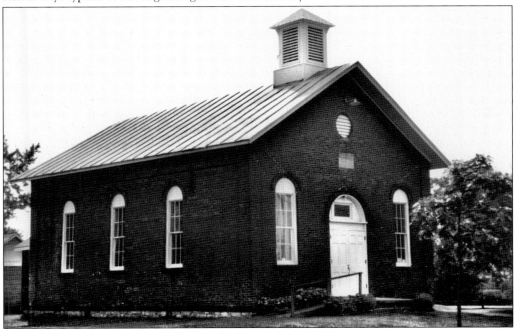

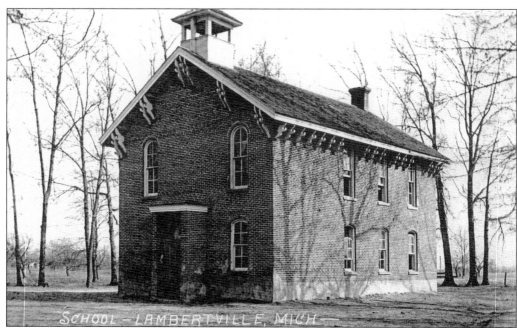

DISTRICT NO. 4, LAMBERTVILLE SCHOOL. The first District No. 4 school was a wooden structure, built in 1835 and located on the north side of Monroe Road. The second school was the above two-story red brick building, with lower grades on the first floor and upper grades on the second. This building was damaged heavily during the cyclone of 1920. The third school, the much larger red brick building seen below, was built in 1922. In the 1930s, a gymnasium was added as a WPA project. The school operated from about 1922 until 1969, when it became the new location of the Bedford public school administration offices. Today this structure houses Olde Schoolhouse Commons, a quaint collection of stores, boutiques, and a restaurant. The Lambertville High School reunions are also held here the first Sunday in August.

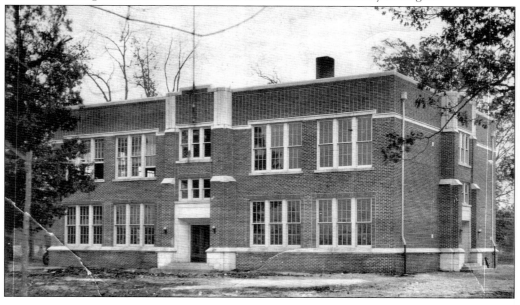

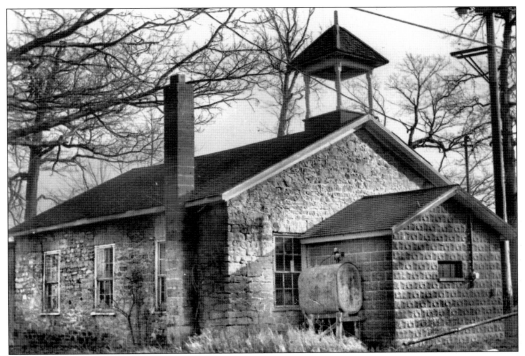

STONE SCHOOL IS THE OLDEST SCHOOL STANDING IN THE TOWNSHIP. Distric No. 7 first had a log school located on Lakeside (Samaria) Road. In 1855, Stone School was built on a half acre of land purchased for $16 on Crabb Road between Erie and Samaria Roads. It cost $407.74 and a stove was purchased for $14. In the 1940s, a portable building housed the primary grades while the stone building housed the grammar grades. The last teachers here were sisters, Julia Wehner and Genevieve Grasley.

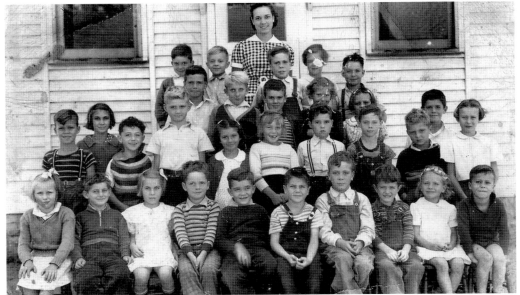

CLASS AT STONE SCHOOL. Miss Eiler's class poses in front of the new portable building in 1940.

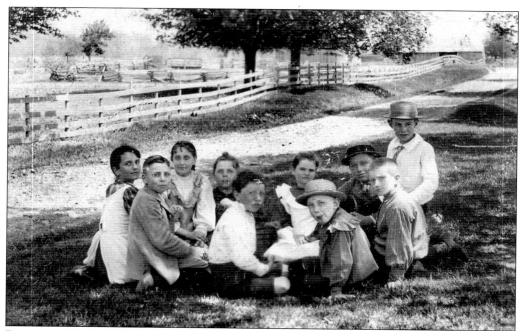

RECESS AT LIBERTY CORNERS. A group of children enjoys a brief recess from studies at Liberty Corners School. In this *c.* 1890 photograph, note the pork-pie hats and the wide-open spaces in the background.

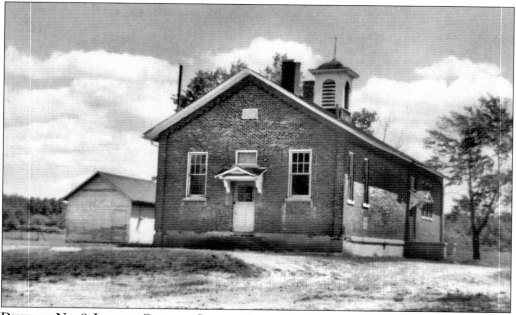

DISTRICT NO. 9, LIBERTY CORNERS SCHOOL. Located at the corner of Sterns Road and Jackman on land donated by the Bibb family, this school was built in 1869 by Frank W. Ludwig, who would build the Banner Oak School two years later. Howard Schuler, a local artist, attended as a boy and has created several sketches of both the interior and exterior of this graceful building.

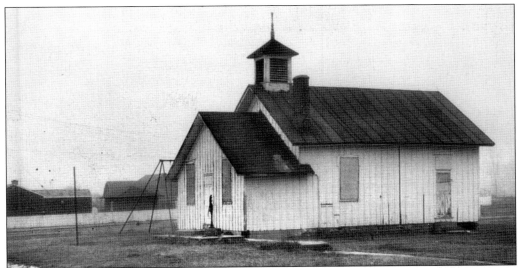

DISTRICT NO. 10, FRENCH WAYSIDE SCHOOL, CRABB AND SUBSTATION ROADS. Built on land donated by the Miller family in 1878, the above school mainly educated French-speaking children. Teacher Grace Kerstetter always referred to it as her "little French School by the Wayside," and the name changed accordingly. Below is a portable building where Sarah Shinkles's class of 1934 learned. By 1947, the building was just used for storage and was demolished by a high wind, which took off the roof and walls and deposited the piano on top of the furnace (witnessed by teacher Mary Morin). Appropriately the last teacher at Wayside School was Grace Kerstetter Stratton, who taught all grades back in 1924 and taught fourth graders there in 1953–1954. She turned the key for the last time in 1954. The abandoned building was burned down by the Bedford Volunteer Fire Department as a training exercise on November 15, 1967. The area was named Ralph Miller Park, after the son of the original donors of the land, Ida and Erwin Miller.

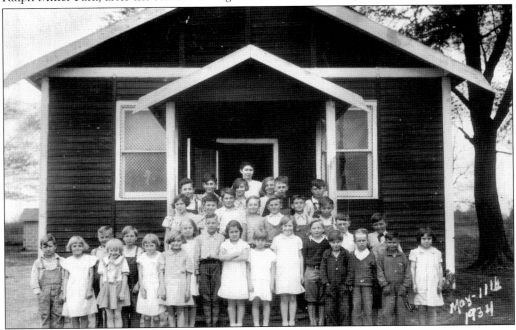

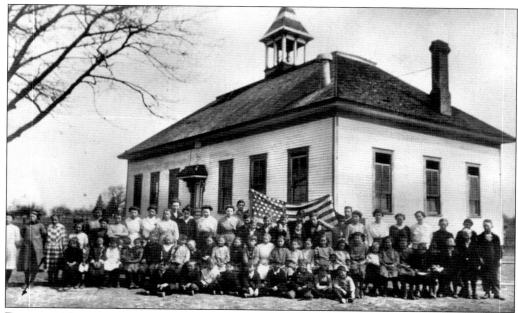

DISTRICT NO. 3, SAMARIA SCHOOL. Built in 1865, the District No. 3 school was originally a one-room wooden structure on Jackman Road on Hungerford family property. About 1900, that building was sold for $57.25, moved to Samaria, and attached to the Willard Store. Pictured is the second school at this site, a two-room wooden structure, which was leveled in the cyclone of 1920. The final Samaria School was built of red brick and completed in 1922. Located at the corner of Jackman and Samaria Roads, it was used as a school until 1970, when it was renovated as the Bedford Senior Center.

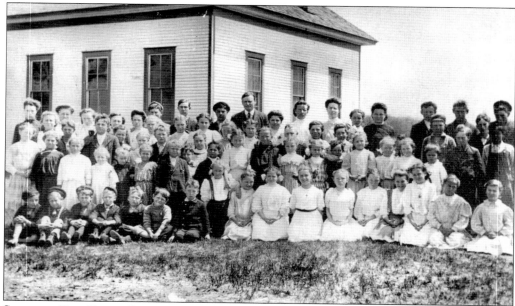

SAMARIA TWO-ROOM SCHOOLHOUSE, 1910. Teachers Clarence Harwick and Alice Parmelee appear here with their students.

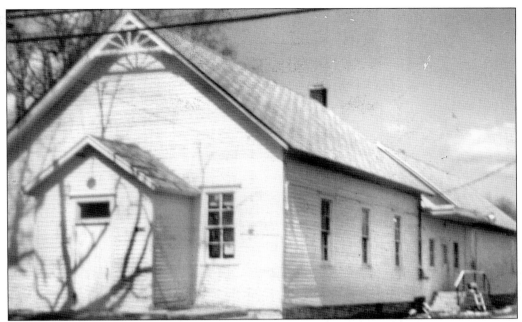

DELAND SCHOOL, DISTRICT NO. 1 FRACTIONAL SCHOOL. Built about 1870 at the corner of Route 151 and Summerfield Road, it was the second school at this site. Lyda Montri Venia, former student, describes, "one large room, about 30 feet by 50 feet, with four rows of double desks and benches for approximately 75 pupils. . . . In back were two cloakrooms, one for boys and one for girls, with hooks on the wall for coats and a shelf for lunches. In the corner at the back was a long stove that burned cordwood." The blackboard was across the front wall in back of the teacher's desk, which was on a raised platform. Writing tools were individual 8-by-10-inch slates with a real sponge eraser; older students used straight pens and ink. Due to overcrowding about 1951, the little Iott School from Whiteford was attached at the rear, with a cloakroom in the middle that served both structures. Below is Mrs. Ault's students at the Deland School.

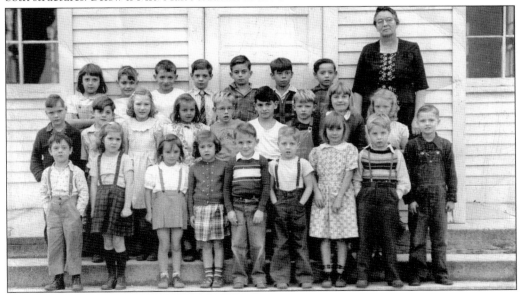

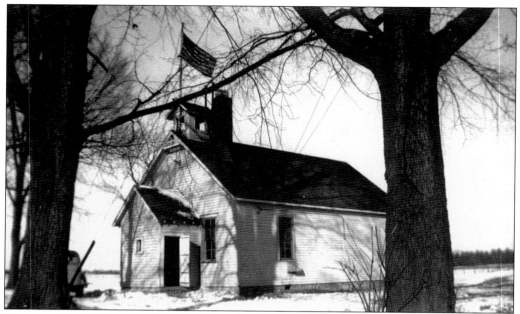

DISTRICT NO. 1, BULLOCK SCHOOL. Named for an early settler, this 1892 school was a landmark at the curve of Secor Road and Route 151. Most students were drawn from the old Deland District. During World War I, Madeline Johnson Elliot Reger taught about 60 students there and earned $60 per month. The last teacher was Esther Kasmatka Tucker, in the mid-1940s. She began by sharing the split sessions with another teacher, but ended up teaching all eight grades. The school burned one night in March 1945. After that, students attended classes in the basement of St. Anthony's Church until Bedford schools became consolidated.

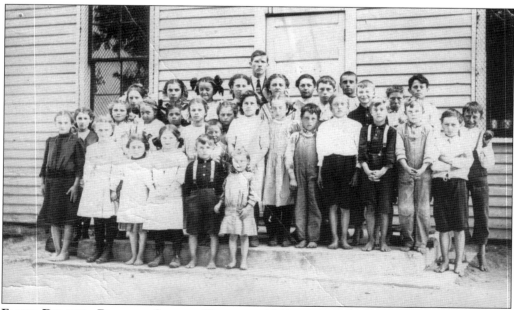

FLOYD DELAND, BULLOCK SCHOOL TEACHER, 1913–1914. Deland is pictured here with his "shoeless wonders."

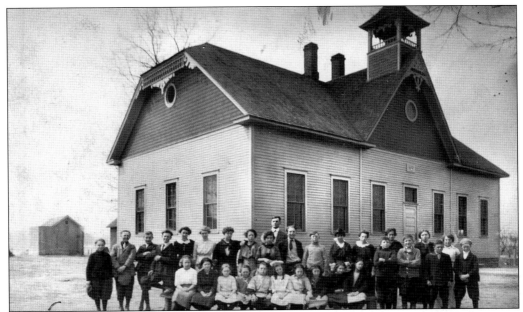

DISTRICT NO. 2, TEMPERANCE SCHOOL. The second school on Temperance Road was built after the tiny Center School was outgrown. Through the years, additions were made to accommodate the increasing student population. As shown below, the building burned in February 1946, causing the school board to consider consolidation of the rural schools of Bedford Township. Temperance students briefly attended the Lambertville School, and then arrangements were made to bus students to the Hamilton School in Toledo until a new brick school could be built on Douglas Road.

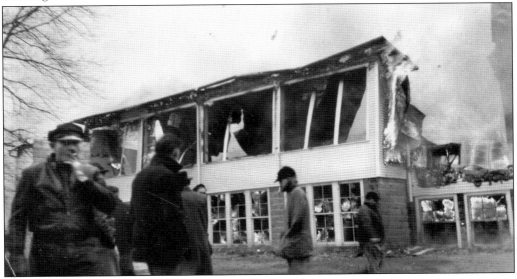

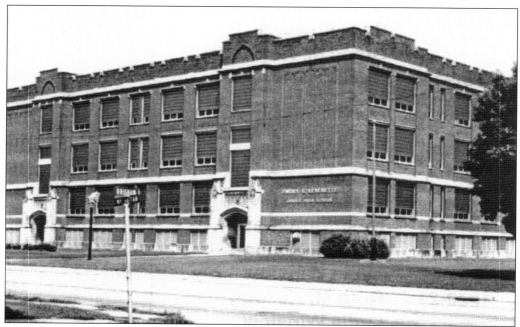

FORMER HAMILTON SCHOOL, TOLEDO, OHIO. Because both Bullock and Temperance Schools had burned within a one year period, Toledo's Hamilton School became a temporary home away from home for Bedford Township students, and the change would be historic. The school board then decided to consolidate all the individual rural schools into one system, the Bedford Rural Agricultural School System. The school system was formed in 1946 and construction began on one centralized brick school building.

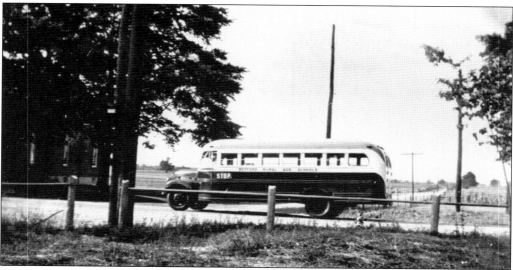

FOR SOME, WALKING TO SCHOOL WAS SIMPLY OUT OF THE QUESTION. Because of the distance involved in the temporary housing, some Bedford area students would be transported in the first school buses, painted a patriotic red, white, and blue and driven by teachers. An outcome of this would be the invention of the bus safety mirror by Reid Stout.

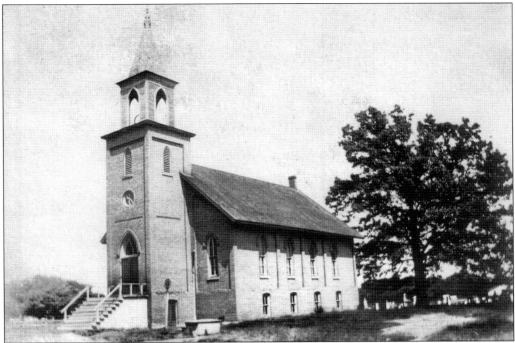

LAMBERTVILLE METHODIST CHURCH. Perhaps the oldest in the area, this church was built on land donated by John Lambert for a meeting place and burial ground in 1844. Because the population was small, preachers were circuit riders, going on horseback to the various parishes. Lambertville, Samaria, and Lulu were the three towns on the early Methodist church circuit riders regular route.

LAMBERTVILLE'S MISSIONARY BAND. The missionary band was not a musical group, but a sewing circle connected with the Methodist church. The women made quilts to raise money for missions.

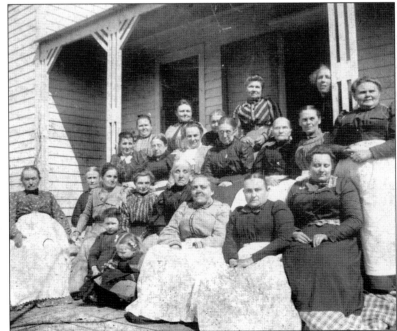

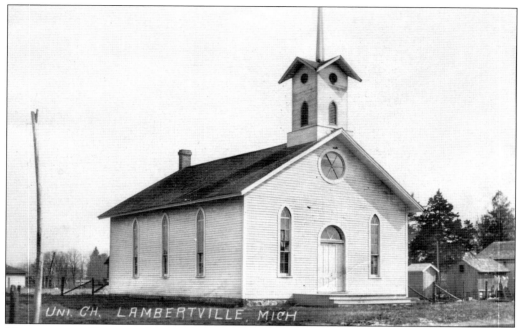

UNIVERSALIST CHURCH, LAMBERTVILLE. Located on Monroe Road, next to the Lambertville Cemetery, this church was built in the mid-1800s and was attended until the 1920s. Sunday school records dated 1871 were kept by Anna Janney. There seems to have been competition between the boys and girls as to how many Bible verses they could memorize. The score was boys 422, girls 650. The abandoned church was then used for basketball practice by Lambertville High School. Just before the building was demolished, Harold Smith took up the hardwood flooring and used it in his home on Smith Road.

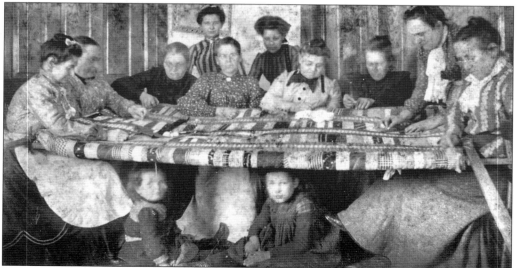

QUILTING BEE, LAMBERTVILLE, MICHIGAN, FEBRUARY 18, 1903. Pictured here are, from left to right, (under table) Beryl Kinney Nokes and Nita Kinney Eicher; (around the table) Mrs. Klieber, Amelia Stratton, Mary Slick, Mary Boice, Eliza Ley, N. Kinney, Rose Spalding, and Jennie Thomas; (standing) Elsie Klieber and Hazel Kinney.

SAMARIA'S GRACE METHODIST EPISCOPAL CHURCH. The beautiful stained glass windows were not part of the original church. Added after the cyclone of 1920, these windows were donated as memorials to Rev. George Thurston, Silas L. Smith, Dr. George Canen, Lemuel Johnston, Frank Smith, Claude B. Sorter, Sherman Osborn, Daniel R. Bolton, and Mr. and Mrs. Joseph Johnston. The original church was built on this land donated by Joseph's widow, Hepzibah Johnston, and was constructed through the donations and labor of dedicated members. They met their goal, which was to open in the spring of 1894, debt free. They celebrated with a special children's day program. Today the church is an integral part of the community with its special dinners and rummage sales. For years it has served as headquarters for the annual Samaria Day celebration, the second Saturday in June. Also at the annual Christmas tree lighting at Samaria's Sportsman's Park, the church bell ringers help raise a joyful noise.

HISTORY OF THE FREE WILL BAPTIST CHURCH OF BEDFORD. According to the "Observer" column of the *Monroe Evening News*, "On May 4, 1844, Elders John Thomas and Enoch Drew, John Lambert, for whom Lambertville was named, Mary McLouth, Manervy Twichel, Herman C. Smith, Sister Jackson and Sister Clark, so the centennial history recalls, journeyed over Indian trails as far as ten miles to meet together to organize the First Free Will Baptist Church of Bedford and Erie townships. . . . Original services were conducted in a log house two miles north and a mile east of Temperance at Samaria and Geiger roads. Later the church moved into the stone school a half mile south on Geiger road. By 1851 the congregation built its first edifice, a structure 24 by 36, dedicated in December and located on the present site of the Erie Evangelical church at Samaria and Cemetery roads. Women sat on one side of the church, men on the other, and are listed separately as brethren and sisters in the early records. Leading members in this period, in addition to the pioneers, included the Bradford, Hubbell, Parmington, Winslow, Nicholson, Bitenbender, Addison, Loose and Werman families. . . . Early pastors were Elder Thomas, the first, from 1844 to 1851, the Rev. W. S. Warren, 1851 to 1855, the Rev. R. Hayden and the Rev. William Clark, 1855 to 1861, the Rev. Warren King, 1861 to 1866 and the Rev. J. P. Bates in the latter year." During the Civil War, many members left for armed service so attendance was sporadic. In 1868, a revival was held at the Little Lake Schoolhouse. People liked this more convenient location and decided to move the church. Logs and shingles were hewn of oak by head carpenter Theophilus Osgood, aided by Lewis Willard and William Tuttle. The old building would later be sold to the Erie Evangelical Society to become the German Reform Church. Today the building at this site at 1100 Samaria Road is the Erie United Methodist Church. The Erie Union Cemetery lies nearby.

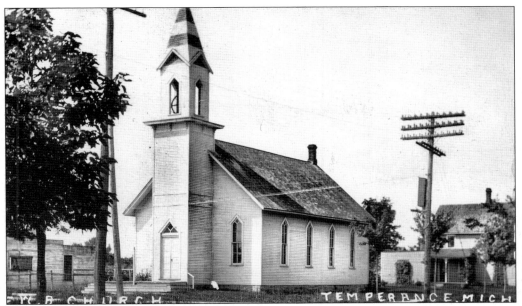

New First Baptist Church of Temperance. Completed in December 1893 at the cost of $1,400, the building was free of debt at the dedication. When the Reverend J. W. Tolly was pastor, the parsonage had to be enlarged to accommodate his family of eight children. The church and parsonage were wired for electricity in 1920, replacing the old, wood, alcohol-primed lamps.

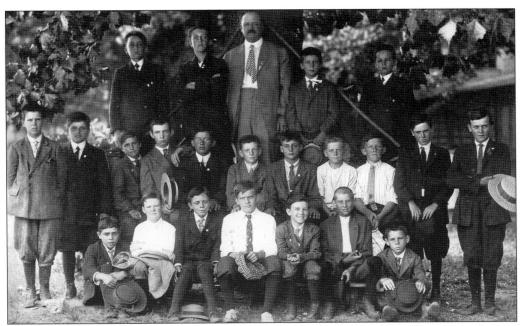

Baptist Church Sunday School Class. The boys' Sunday school class at the Baptist church was taught by Sam Wallace, owner of the Temperance Bank. Seated fourth from the left is Ellsworth "Dick" Moyer, who would later become the town barber. On Dick's left is Milton Carr, who would donate the six-acre Carr's Grove to the town of Temperance.

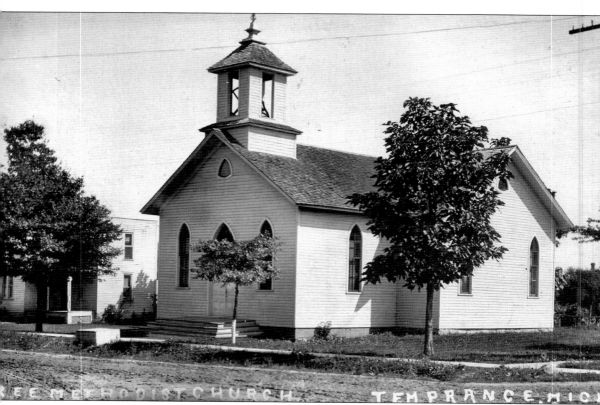

FREE WILL METHODIST CHURCH, MAIN STREET AND OLD U.S. ROUTE 23. Originally organized in a little white schoolhouse north of Ida, the church was moved to many locations over the years. This building opened in 1882, serving its members well until they outgrew the space. In the early days, horse-drawn carriages deposited members at the concrete block in front of the entrance. In 1965, when off-street parking for automobiles became a problem, the congregation decided to build a new church and move to 1590 West Temperance Road. The name changed to Crossroads Community Church, and the old building was demolished in 1966. A Shell service station was built at this site, followed by a Peoples Savings Bank, and now M and C's Corner Café.

ORIGINAL ST. PAUL'S CHURCH, LEWIS AVENUE. Members began meeting in homes in Temperance in 1914. In 1915, they met every other Sunday at the Baptist church with Rev. Andrew Rohn. In 1937, St. Paul's Evangelical Lutheran Church was built on Lewis Avenue at North Park. The congregation grew, and a new brick church was constructed across Lewis Avenue on a much larger piece of property. The dedication of the new church, pictured below, occurred on February 12, 1956. An educational addition was built in 1970 to accommodate a preschool and Head Start program. Rev. Dr. Rodney K. Haselhuhn is the current pastor of St. Paul's Evangelical Lutheran Church, shown below.

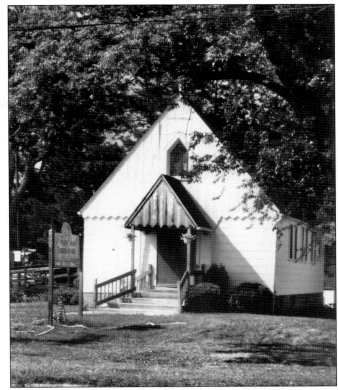

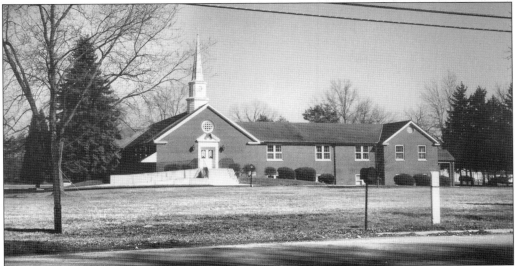

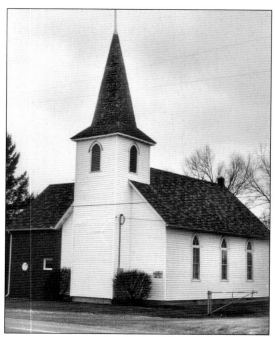

WESLEYAN CHURCH, DELAND'S CORNERS. Hall Deland organized a religious group whose first meetings were held in the little white Deland Schoolhouse. As the congregation grew, a church was built just south of there around 1891. Structural changes have been made over the years, and the name was recently changed to Countryside Wesleyan Church.

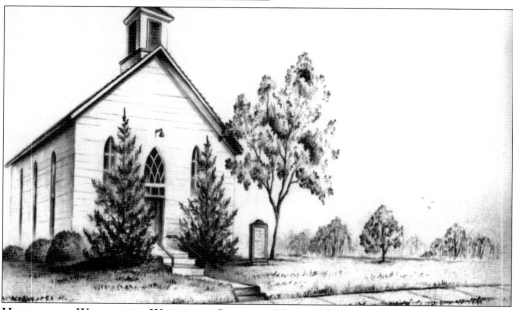

HISTORY OF WHITEFORD WESLEYAN CHURCH. The 150th anniversary booklet relates the history of the Whiteford Wesleyan Church. The "Happening" in 1920, when Evangelist Lewis King was invited to speak at a revival service at the church, might catch your attention. King's attitude against Catholics had roused 11 men from Erie and 10 from St. Anthony to attend the revival. They were led outside by unarmed special deputies who were on duty that night, and who decided to rush home to "get their guns." A melee ensued "with at least 50 gun shots being fired. When it was all over, one protester laid dead, one died later and two others were injured. The trial that followed was one of the largest attended in Monroe County."

CHURCH AT LIBERTY CORNERS. The First Wesleyan Methodist Church at Liberty Corners, Sterns at Jackman Road, was built and bricked by Reverend Sellick in 1880 on land donated by Richard and Ann Bibb. In the 1920s, this was the community Sunday school. In 1929, the Liberty Corners Ladies Aid bought the church, continuing the Sunday school program. Next this became Rev. Zeitner's Mission with about 54 charter members under the auspices of the American Lutheran Church. Around 1953, the name was changed to St. Luke's Lutheran. In 1963, ground was broken for a new building across the street. Jayne Kaemming wrote a detailed history, which is on file at the library.

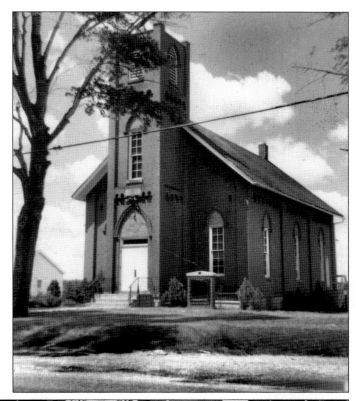

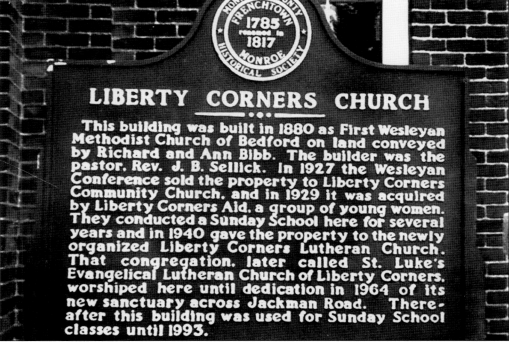

MONROE COUNTY
FRENCHTOWN
1785
renamed in
1817
MONROE
HISTORICAL SOCIETY

LIBERTY CORNERS CHURCH

This building was built in 1880 as First Wesleyan Methodist Church of Bedford on land conveyed by Richard and Ann Bibb. The builder was the pastor, Rev. J. B. Sellick. In 1927 the Wesleyan Conference sold the property to Liberty Corners Community Church, and in 1929 it was acquired by Liberty Corners Aid, a group of young women. They conducted a Sunday School here for several years and in 1940 gave the property to the newly organized Liberty Corners Lutheran Church. That congregation, later called St. Luke's Evangelical Lutheran Church of Liberty Corners, worshiped here until dedication in 1964 of its new sanctuary across Jackman Road. Thereafter this building was used for Sunday School classes until 1993.

HISTORIC SIGN. This sign was donated by Bill Winson, former Bedford Township supervisor.

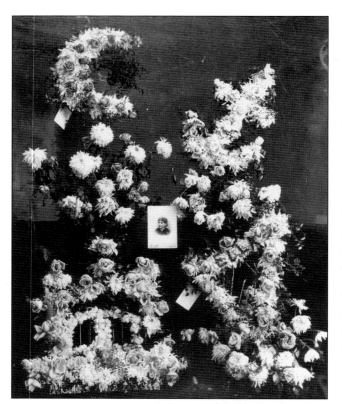

A FUNERAL IN BEDFORD TOWNSHIP. Traditionally photographs were taken of floral arrangements before a procession to the cemetery. The arrangements shown here were for Ella S. Laskey (née Pickard), who died in 1899, leaving two young sons. We see a symbolic harp and heavenly gates. Only two Catholic churches are located in Bedford Township, St. Anthony's and Our Lady Of Mount Carmel, begun in 1969, each with a cemetery nearby. St. Anthony's Catholic Church was built in 1907. The original cemetery was located behind the church (now the site of the current school) on land purchased for $150. Cemetery lots at the time cost $5 each. This cemetery was moved to Erie Road between Secor and Douglas.

FUNERAL FLOWERS. This 1901 photograph shows floral arrangements for Mrs. Fred Smith (Euphemia Newcombe). Note the unique wheel with a broken spoke in the bottom left corner, indicating the journey ahead will be a difficult one for those she left behind.

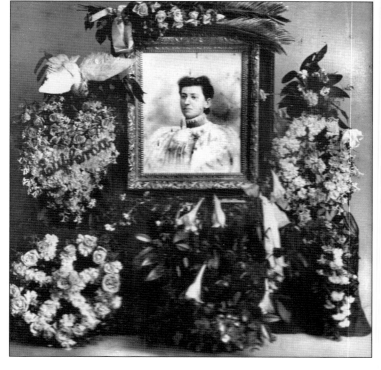

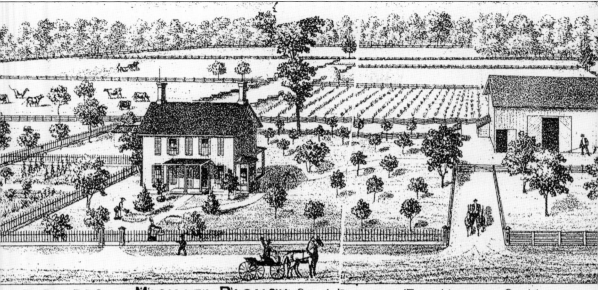

FARM RES. OF MICHAEL BLOUCH, SEC.1 BEDFORD TWP. MONROE CO. MICH.

BLOUCH FARMSTEAD, BEERS 1876 ATLAS OF MONROE COUNTY. Blouch-Osgood Cemetery, located on the north side of County Road 151 in Section 1 of Bedford Township, was a joint venture between the Theophilus Osgood and Michael Blouch families, joined when young Thomas Blouch married Martha Mary Osgood, daughter of Theophilus. The first interment at the cemetery was in 1834. Since then, over 300 people have been buried here, including infants in a special section. Native Americans are also buried here, because in the earliest days, they lived and worked the fields behind the Osgood homestead. However since they did not believe in marking graves, they cannot be identified. Bedford Township now operates this old family cemetery and has renamed it Bedford Memorial, pictured below.

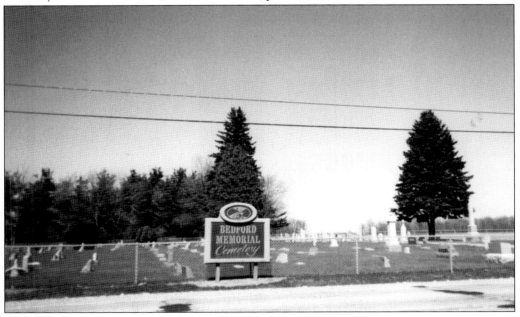

LAMBERTVILLE CEMETERY CASKET WAGON, MONROE ROAD, LAMBERTVILLE. The cemetery property was originally donated by John Lambert for a meeting place and burial ground. The first person buried there was Abigail Wood Thornton, in 1836. This is also the site of the annual Lambertville Memorial Day Parade and ceremony. Howard Schuler, master at arms for the event for 38 years, is buried here.

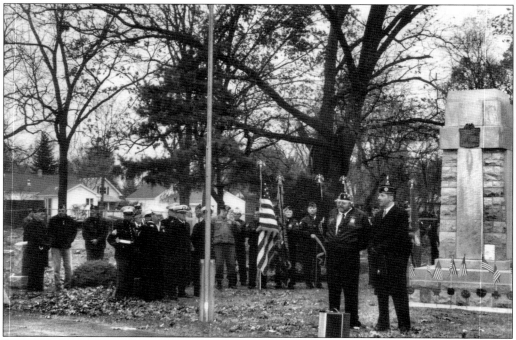

LAMBERTVILLE MEMORIAL DAY PARADE. Lively parade participants are en route to the cemetery monument, originally designed by Howard Schuler. The monument honors fallen soldiers of all wars. The graves are decorated with flags every Memorial Day by members of the American Legion and Veterans of Foreign Wars groups.

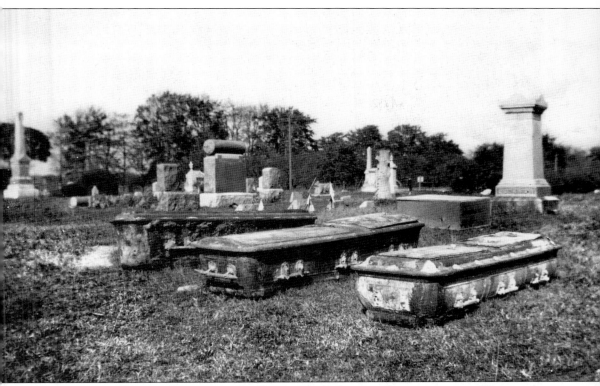

POWLESLAND FAMILY GLASS-TOPPED CASKETS, AWAITING RE-BURIAL AT WHITEFORD CEMETERY. The deceased in the Southard Cemetery on Alexis Road were removed around 1944 to make way for the construction of a propeller plant during World War II. The majority of the deceased were re-interred elsewhere, many in Collingwood Cemetery in Toledo. Whiteford Union Cemetery is located on Sterns Road, and VanAuken Cemetery is just around the corner on Whiteford Center Road. Members of the Billau family have been sextons of these two cemeteries for 119 years. Most of the people buried in Whiteford Union are from Bedford Township. Both cemeteries hold soldiers from every engagement since the War of 1812. The most recent veteran's grave is that of Marine Corps Pfc. Juan Garcia Jr., killed in action in Baghdad on April 8, 2003. Bedford resident Harley Hartline has, at his own expense, placed an American flag on every veteran's grave each Memorial Day for the past 40 years.

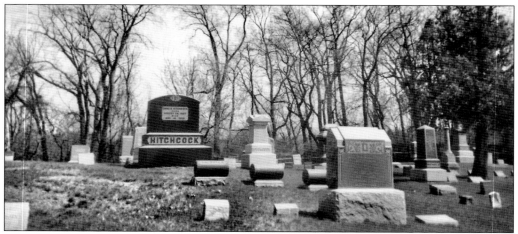

HITCHCOCK FAMILY CEMETERY ATOP A WINDY HILL, LEWIS AND STERNS, TEMPERANCE.
Hitchcock Cemetery began as a family cemetery. Elisha B. Hitchcock and several of his sons built their homes here at "Hitchcock's Corners." James was a justice of the peace, who held court in his parlor for many years. Chester held many political offices. There were several educators in the family. Hitchcock genealogies done by Elizabeth May show connections to Laskey, Pickard, Aysh, Kinney, Lewis, Osgood, Pelton, Candee, Rawson, Southard, May, Quelch, Viets, and Clark. One Revolutionary War veteran, Samuel Adams (1762–1847), is buried in Hitchcock Cemetery. One Hitchcock house at 7300 Lewis Avenue became the Lindecker home for over 40 years. The house was demolished in 2004.

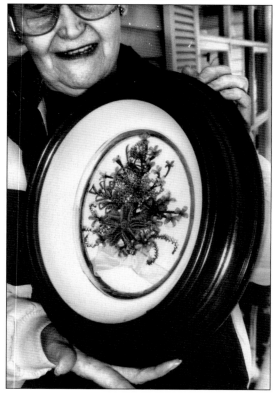

FAMILY KEEPSAKE. Belonging to Letha Eighmey Mills, this keepsake incorporates in its intricate floral designs locks of hair of various deceased members of the Pickard family. It was a Victorian custom, as were photographing funeral flowers and wearing of black.

Three

TAKING CARE OF BUSINESS

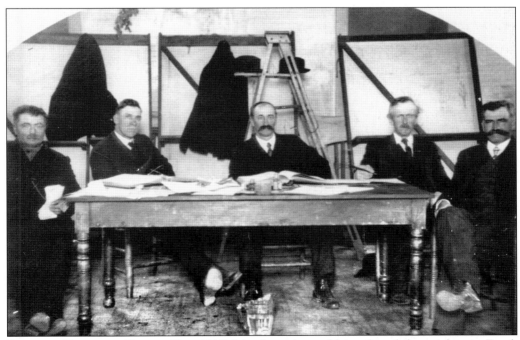

BEDFORD TOWNSHIP BOARD, PRE-1916. Members pictured here, from left to right, are Frank Brunt, Chester Hitchcock, Clarence Janney, John Hummel, and Ira Osborn.

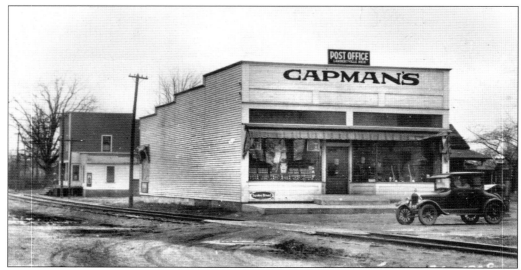

Downtown Lambertville, Summerfield and Monroe Roads. Stores have occupied this corner since 1850, with Quelch's followed by D. Taylor, Sam Bibbins, William Opdyke, and William Green. In 1930, Harper Capman owned a grocery store that also served as the post office. Lawyers Bill Winson and Tom Pruden had offices here from 1958 to 1963. Mary Kay's Beauty Salon was also in this building. Tom Townsend's Carpeting has done a thriving business at this corner since 1969.

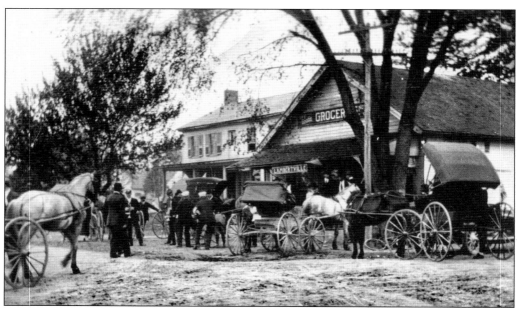

Opposite Corner, Summerfield and Monroe. Business at this corner dates to 1876, when J. J. Sumner built the first of several general stores at this location. Subsequent owners included Jacob Slick, George Farrell, and Roy Whittaker. The father of Marlene Sterling (née Himburg) ran a gun shop here and tested the rifles out back. A quieter business was the Jack and Jill Photography Studio, which closed down in the 1970s. Since then, the building has become a private residence

ED OPDYKE'S GROCERY STORE.
As a youth, Ed had worked in his father's blacksmith shop on Summerfield Road next to the Odd Fellows hall. However by 1923 he wanted a less strenuous occupation. Ed and his wife Lucy and daughter Helen opened a grocery store located across from Doc Parmelee's home and office on Summerfield, north of Monroe Road. When Ed retired in the late 1930s, the tiny store building was moved to the rear of the Lambertville School property for a library, operated by Viola Emery from 1943 until 1954.

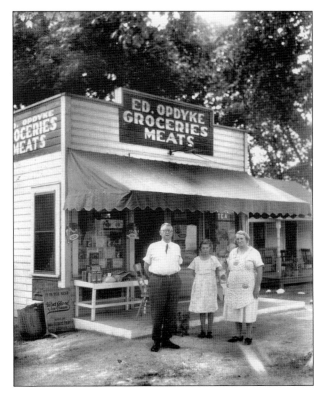

SLICK'S SLAUGHTERHOUSE, LAMBERTVILLE. Bill Hobart operated this slaughterhouse as a profitable business. The concrete slab floor can be found beneath many years' accumulation of weeds.

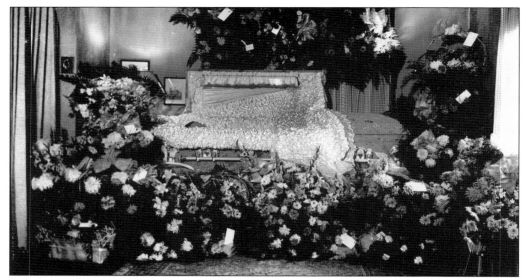

LUCIUS FARNHAM, LAMBERTVILLE UNDERTAKER. Following the custom of the times, Lucius laid out the deceased's casket in the front parlor of the home. Descendants have been operating the funeral home in Temperance since 1927. Young Taylor Farnham received his Embalming School diploma in 1923 and carried on the family business. Farnhams also provided ambulance service to local hospitals. The business, still in the family, is a landmark in Temperance.

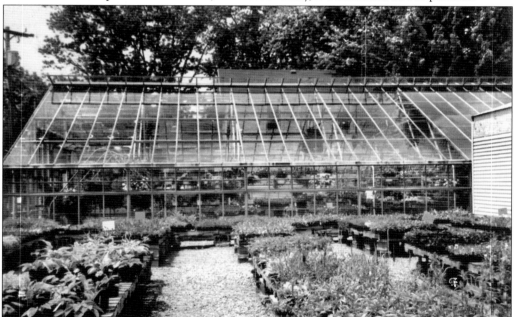

BROCK CENTENNIAL FARM AND GREENHOUSE, 2925 SMITH ROAD. Originally the 40-acre farm of William R. Powlesland (1825–1891) and Jane Powlesland (née Mortemore, 1831–1895), the property passed to their only daughter, Caroline G. (1851–1926) and her husband, Frank G. Jackman (1849–1914). The map of 1920 shows William P. Jackman and the maps from 1955 to 1975 show Warren "Kite" Brock and Margaret Brock (née Hartz) as owners. Warren died in 1982 and Margaret in 1986. They are buried in Lambertville Cemetery.

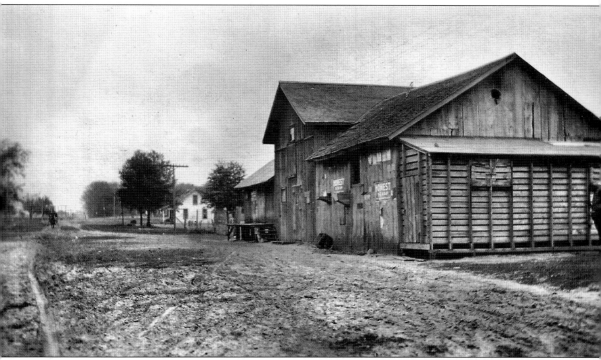

DENNISS CIDER MILL, LAMBERTVILLE. Torn down in 1940, this structure was originally built as a feed mill around 1895 by Mr. Van Orman. It was enlarged, allowing for cider making, through use of steam power. Mr. Davis purchased half interest in the mill, and the thriving business often operated well into the night. Charlie Denniss then purchased the mill, discontinued the sawing of lumber, and installed a gasoline engine to help press apples and grind grain. Every fall, mountains of leavings, pulp left from squeezing apples for cider, would attract both bees and the neighborhood children, who knew that a free cup of cider was available.

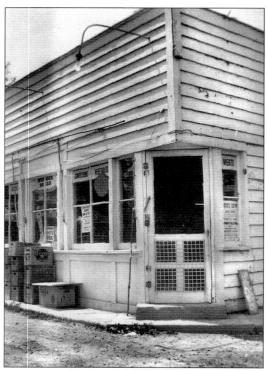

WATKINS GROCERY, 7723 SUMMERFIELD ROAD AND MAPLEWOOD. This tiny white building was initially run as a mom-and-pop grocery by the Watkins family, pioneers in this area. The store was sold in 1953 to Vera and Robert Flick, who later painted the store party red. In 1979, they erected a larger building at Sterns and Secor in the new downtown area of Lambertville. Their daughter Linda Flick, the current owner, tells us that Flick's celebrated its 50th anniversary in Lambertville in 2003; its motto is "We cater to you."

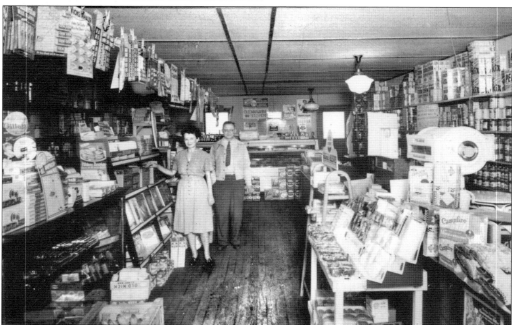

GLEN AND MARIE CLEVER'S MARKET. This typical mom-and-pop grocery operated on Secor Road in Lambertville from about 1944 to 1961. The Clevers sold to Ed Seegert, who then sold to Gary Snyder. Both ran the business under the name Tony's Country Store, which became famous for its pizza and donuts.

REID STOUT, INVENTOR OF THE BUS SAFETY MIRROR. A beloved school administrator, Stout worked as principal and athletic coach at Lambertville and became superintendent at Temperance. A man of many talents, he invented the convex mirror, which he manufactured with the aid of his wife, Lucille, in the family's two-car garage at the rear of his home on Butternut in Lambertville. It would be known as the Safety Cross Mirror Company.

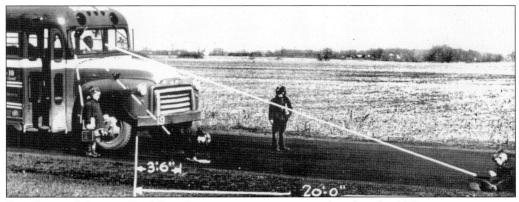

BUS SAFETY MIRROR. Reid Stout's convex mirror was introduced in the 1950s.

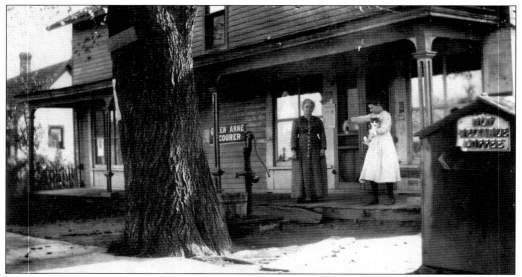

LARGEST GENERAL STORE IN SAMARIA, 1889–1899. Kittie Brunt (née Ansted) stands in front of the store that was formerly Jacob W. Ansted's pride and joy. He advertised, "I sell lower than the lowest." The site also boasted the town pump, which drew more customers since they could water their horses while getting their groceries and other necessities. Jacob Ansted and Mary Ann Ansted (née DeForrest) had seven children.

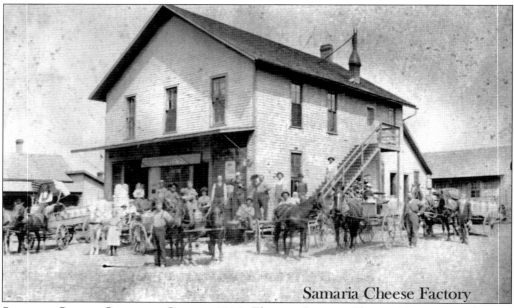

Samaria Cheese Factory

SAMARIA CHEESE COMPANY, OPENED 1896. The new Samaria Cheese Company was located on the first floor of the old Willard Store. The crate factory, producing wooden molds for the cheeses, was situated at the rear. Locals brought sterilized cans of unpasteurized milk from their farms and went home with whey left from the cheese-making process to slop their hogs. Cheese production continued through about 1912. Next came a barbershop and pool hall. By 1914, Samaria Grange No. 1430 had purchased the building and would remain there the next 70 years.

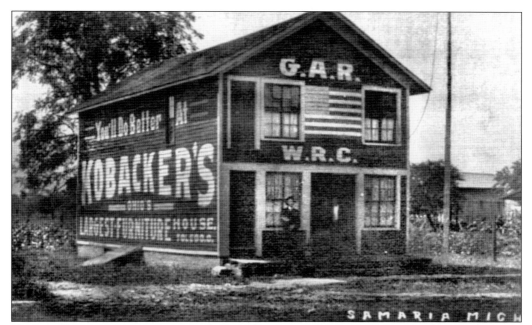

FORMER ELIJAH WEEKS GENERAL STORE, TELEGRAPH, AND MILL. Located at the Samaria tracks, the general store is shown after 1915, when it was the Lawton Post of the Grand Army of the Republic. Later the building was turned, via horse-and-winch, to be parallel with Samaria Road. The building was remodeled into a beautiful Colonial-style home.

SHERMAN OSBORN'S CEMENT BLOCK FACTORY, SAMARIA. Operating near the mill by the railroad tracks, Osborn's produced the best cement blocks around. At the onset of World War I, Sherman enlisted and was killed during his first week in France. A stained-glass window in the Samaria Methodist Church was created in his memory. The Sherman Osborn American Legion Post 192 in Temperance is named in his honor.

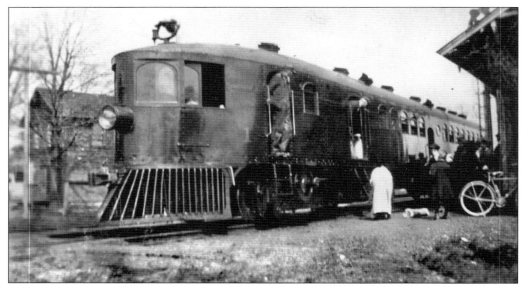

ANN ARBOR TRAIN STOPS AT SAMARIA. The train brought with it passengers, mail, and produce for the Toledo Market. In the background is Tracy's Confectionary, which would become Myrtie Dunbar's grocery and post office. The building remains the site of the post office today.

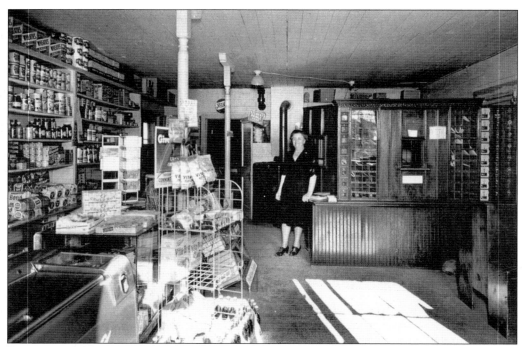

POSTMASTER MYRTIE DUNBAR. Serving as postmaster of Samaria, Michigan, from 1940 until 1957, Myrtie purchased the building and lived upstairs. She ran a grocery store that included booths where people could sit and eat their treats while reading their mail.

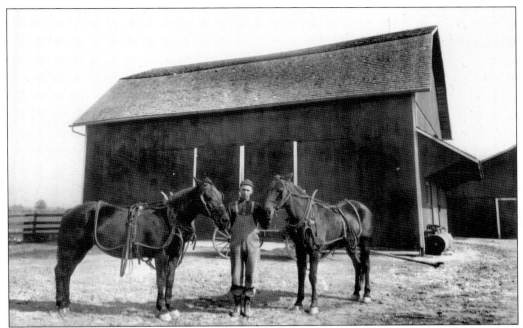

TEAMSTER RUBE WHITING. This youth from Yargerville met his bride to be, Bernice Johnston, while playing Pig in the Parlor at the local Grange Hall in Samaria. They married, had two daughters, and lived the rest of their lives in Samaria. The Whitings were active at the senior center, and Rube was a member of the Green Thumb Gardeners. His favorite song was "The Preacher and the Bear."

REUBEN WHITING, 90TH BIRTHDAY, NOVEMBER 3, 1985. Ten years later, Reuben was still going strong, so his 100th birthday was a greater cause to celebrate with a huge affair held at the Bedford Senior Center with hundreds of friends and relatives in attendance. He passed away on June 5, 1997.

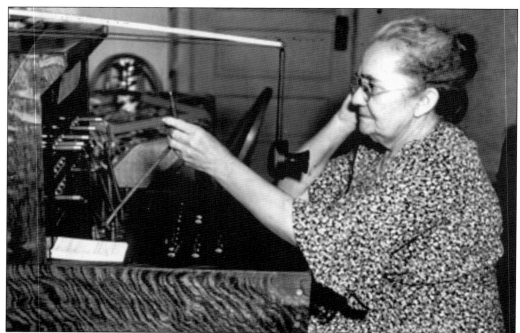

WHITEFORD FARMER'S TELEPHONE COMPANY, SAMARIA. A one-woman operation, Mary Smith Kiefer ran the party-line switchboard for over 30 years. When new dial-up telephones arrived in 1939, she retired and the old crank telephones were gathered into a farmer's field and burned. Once the new automated telephones were installed, special dial-up instructions had to be printed in the one-page telephone directory for the area.

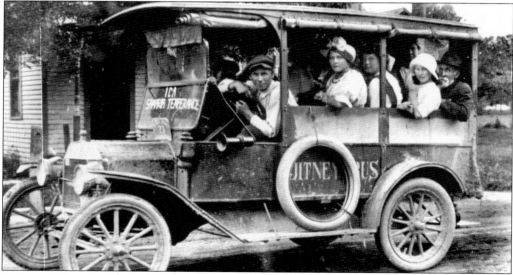

FORREST WRIGHT, JITNEY BUS SERVICE. Operating from 1914 to 1918, this bus service covered Samaria, Temperance, and Ida, delivering folks to Toledo twice a day. Also a Samaria farmer, Forrest had a produce stall at the Toledo Market and a reputation for the best sweet corn, sweet potatoes, and sorghum anywhere. Samarians ordering corn for a family gathering would let him know when they planned to eat, and Forrest would deliver their corn when the water was boiling.

WILLIAM DUNBAR, A MAN OF MANY TALENTS. William was a notary public and sold fire and cyclone insurance from his home when he was not teaching school. He operated the adjacent general merchandise store with his sons from 1907 to 1915. This general store had been originally owned by Mr. Phaender, then Warren Kirkland, then William Dunbar. Later owners Mr and Mrs. Whitmill sold the grocery after being robbed in 1931. Next it was the Grodi family grocery. Eventually the building became the Bedford Cooperative Nursery, followed by a Baptist church. Currently it contains builders' offices.

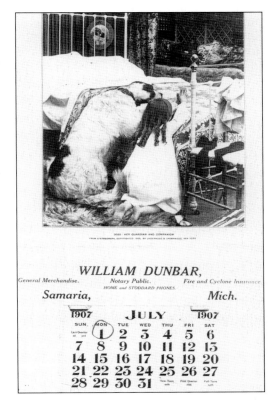

WILLIAM DUNBAR,

General Merchandise. Notary Public. Fire and Cyclone Insurance
 HOME and STODDARD PHONES.

Samaria, Mich.

1907 JULY 1907

SUN.	MON	TUE	WED	THU	FRI	SAT
	1	2	3	4	5	6
7	8	9	10	11	12	13
14	15	16	17	18	19	20
21	22	23	24	25	26	27
28	29	30	31			

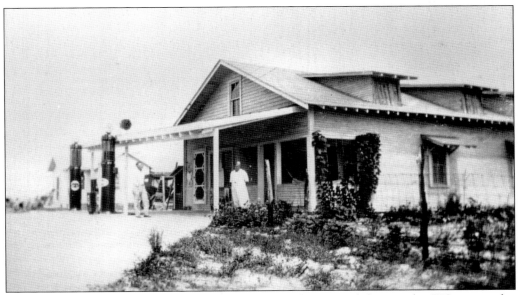

BULLOCKS CORNERS GROCERY. Legend states that during Prohibition, the FBI cornered a bootlegger here and a shoot-out ensued.

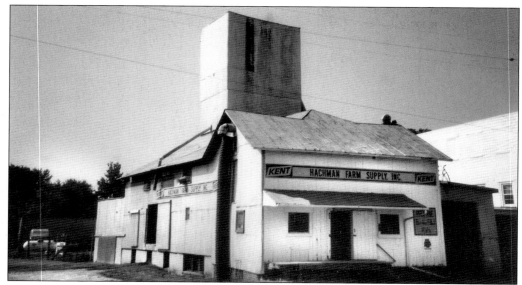

THE MILL, 627 WEST TEMPERANCE. Located next to the railroad tracks, this mill, operated by William and Harry Hachman, had been in operation since 1941. It replaced an earlier mill, which was owned by Joseph and Cyrus Cowell, but was destroyed by fire in 1895 and then later was rebuilt. A grain elevator was once located here, and farmers lined the road, waiting to dump their grain. The elevator was remodeled in 1947. Bill Mannor operates the mill today and runs the feed store next door.

FEED STORE. Hachman's Feed Store was once the Moore Extract Company and, at the end of World War II, the Button Factory for ruptured ducks, gold-plated plastic lapel pins men and women wore on their uniforms after discharge (to get home without being arrested for being AWOL). In both Temperance and Samaria, the Extract Companies of Len Segur operated under the name Meader Laboratories. In an interview with Len, he confided that the secret to his success with flavorings was a water base, whereas his competition used oil, which turned when it got old.

TEMPERANCE SMITHY. Thanks to artist Howard Schuler, who created this sketch, so many scenes from the Bedford Township area that otherwise would have been lost have been preserved.

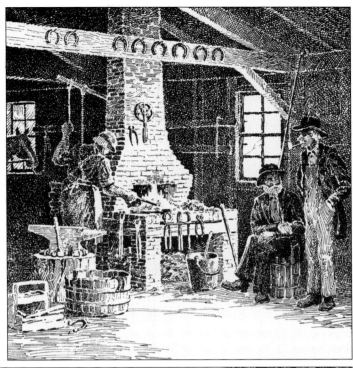

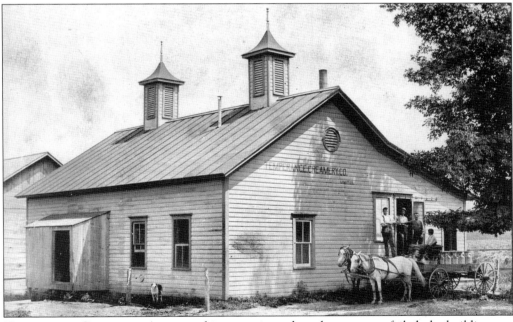

TEMPERANCE CREAMERY. A partnership operation, when the creamery failed, the building was purchased by the Sherman Osborn Post 192 of the American Legion. The hall still stands today, between the World War II tank and the railroad tracks on the north side of Temperance Road, just across from the mill. During World War II, a community bulletin board displayed the names of all the area veterans who served their country.

A. I. Rodd Lumber Company. A local landmark, the lumber company, located on Armstrong Street near the railroad tracks, sold lumber, paint, and roofing and building materials. The building stood empty for some time after Rodd's 1955 death and was finally demolished. Albert I. Rodd and Nellie Rodd (née Wetzel) lived on Orchard Street in Temperance and had four children.

Amos Bigley and Son Furniture and Agricultural Implement Store, 1907. Situated on Main Street (Temperance Road), this store would be more widely known later as Tolly's Hardware. Today it is the location of the popular Village Pizzeria.

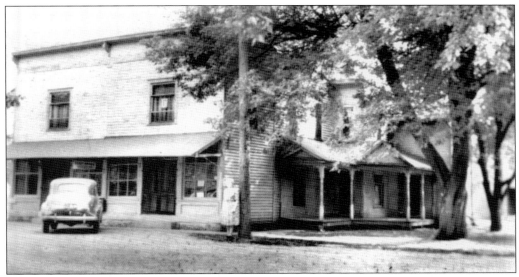

GEORGE KINNEY STORE AND POST OFFICE, TEMPERANCE. Originally Ed Dull owned a grocery store in this building, but beginning in January 1890, it was the George R. Kinney Store and post office at 751 Main Street (Temperance Road). George served as postmaster for Temperance from 1890 until 1915. The building later became the Hotel Wayne, named for Irvin Wayne Kinney and run by his parents, George R. Kinney and Isabell Kinney (née Cowell). A livery and feed barn were situated at the rear of the building. It is believed that Mr. Richardson once had his furniture store and undertaking business here and made caskets in the barn. For many years, Gladys Kinney ran her insurance business here.

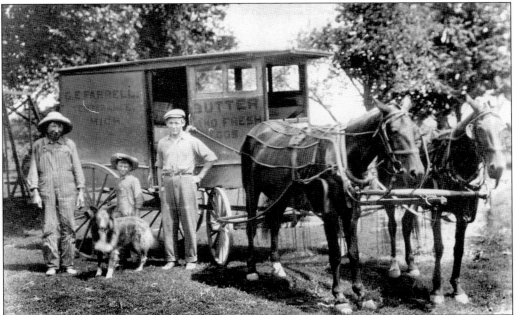

GEORGE E. FARRELL, BUTTER AND EGG DELIVERY SERVICE. Farrell lived in Temperance and delivered his butter and eggs via horse and buggy. A Farrell Grocery was also located in Lambertville at the corner of Summerfield and Monroe.

TEMPERANCE BANK BUILDING. Note the stone marker above, which is currently used as a step at the rear entrance to the Banner Oak School at Sterns and Crabb. Once Millers Grocery, this building later served the community as the *Courier Newspaper* office, a lawyer's office, and then the Latz Soft Water Company, before it became the offices of George Warnke, Bedford Township surveyor. The Bank of Temperance is most remembered because thieves ran off with the safe containing all of its assets. The small but heavy safe was recovered nearby, without its contents.

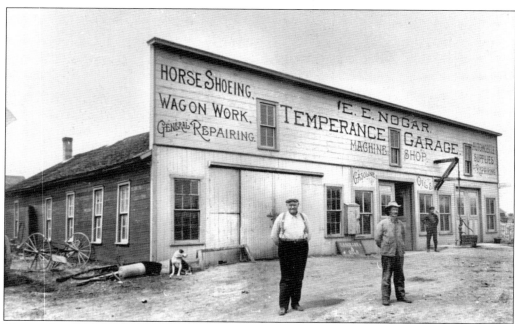

NOGAR GARAGE, TEMPERANCE. Once Ed Nogar's blacksmith shop before World War I, the shop expanded with the times to include automobiles, eventually becoming the Temperance Garage.

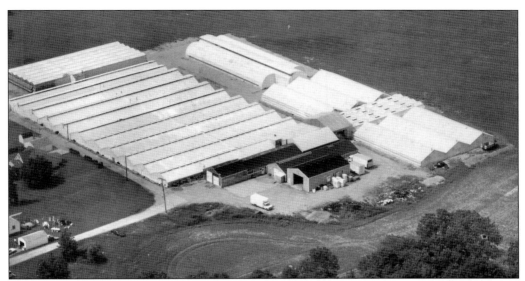

LEHMANN'S GREENHOUSE HAD AERIAL VIEWS TAKEN TO SHOW PROGRESS THROUGH THE YEARS. In 1939, Albert Lehmann and sons, Walter and Irvin, were just getting started in the wholesale business. They purchased land at 6801 Telegraph Road and planted the fields. At first they raised chickens and pigs. Gradually as the wholesale floral business caught on, they put all of their energy into their greenhouses. Their delivery area now services customers from Toledo to Detroit. Young David Lehmann became a partner with his father, Dick, and his uncle, Richard Parker. Lehmann is the fourth generation to proudly carry on the family business of bringing beauty to Bedford and beyond.

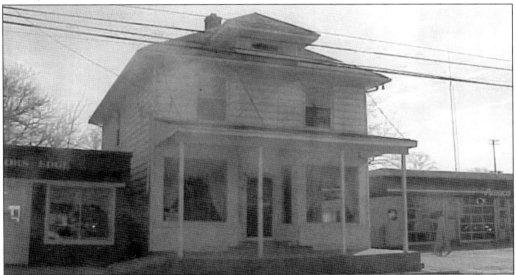

THE POWLESLAND GROCERY AND MEATS STORE, TEMPERANCE. The Powlesland Grocery was just one of many businesses that occupied this site at 9020 Lewis Avenue. Others included the grocery store of Ross Jacobs, who tried to get a liquor license in this dry town. There was such a ruckus that a Law and Order Society was formed. The Jacobs building was purchased by local barbers Martin and his son Dick Moyer, whose family actually lived over the premises. A poolroom was in the back room at one time. Currently this is the location of the Bagel Brothers.

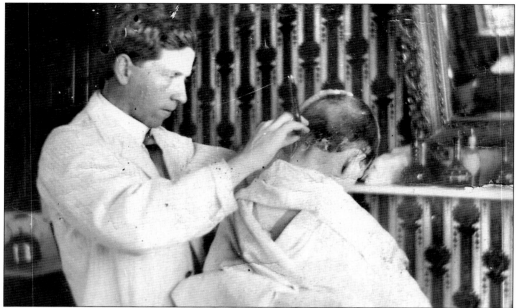

BARBERS IN TEMPERANCE AS EARLY AS 1907. Martin VanBuren Moyer, known as "Mart," practiced his trade in a clean white coat amid homey décor that included wallpaper, as well as the variety of talcums and nostrums on the shelves. Ellsworth "Dick" Moyer, son of Mart, also plied the barber trade in Temperance. Other early barbers of Temperance included Red Billings and Mel and Craig Fleck.

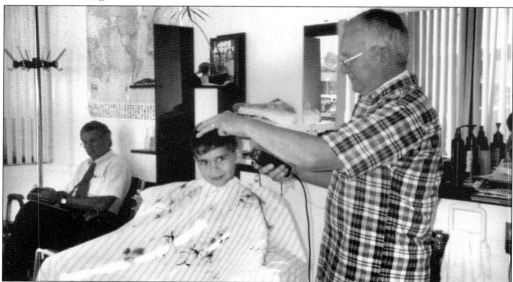

SUBURBANITE BARBERSHOP, STERNS AND SECOR. Ensconced in his tidy two-chair facility, barber Rick Komandera claims, "What is said within these walls, *never* goes beyond." Young Ron Hurley worked here for a while before opening his own Razor's Edge shop in Temperance. That was almost 30 years ago. Another Lambertville barber worthy of mention is Mr. Shoup, who had a shop located next to Capman's store. He kept two pair of boxing gloves handy for any of the local youths who cared to go a few rounds outside on the dirt road to work off energy.

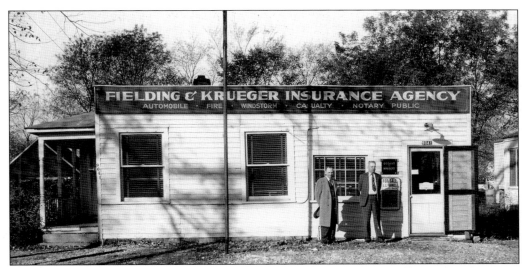

FIELDING AND KRUEGER'S INSURANCE AGENCY, 9041 LEWIS AVENUE, TEMPERANCE, 1946–1951. Originally Mabel Brunt's Insurance in 1930, Albert Stieg's Insurance in 1937, and P. R. Krueger's in 1943, it was Krueger-Harvery from 1955 to 1987. In addition to selling insurance, P. R. and his wife Hazel made stage curtains in his workshop behind their house on Howard Street. P. R. painted a picture in the center of each heavy muslin curtain, then sold the remaining blocks of space for advertising.

BILL FIELDING, TEMPERANCE STATION MASTER, 1920–1945. He was agent and operator, and he handled shipping, receiving, ticket sales, express and Western Union while he blocked the trains to keep them a safe distance apart. He was the bookkeeper, accountant, and janitor. His political career lasted 36 years and included being Bedford Township Supervisor from 1945 to 1957. He was active in community groups, helped organize the Bedford Volunteer Fire Department, and served on the Temperance School Board. A justice of the peace, during World War II he married young service couples without charge. He was in the Chef-O-Van extract business, which made vanilla in a log cabin on Lewis Avenue, and he was the last man in the "Last Man's Club."

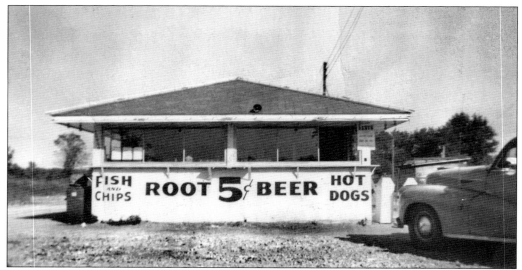

HARVEY AND GRACE BARKIMER'S COUNTRY STORE. They used to have a popcorn machine in front of the old store. Barkimer's took this popcorn booth to all of the free outdoor movies in the area and had a thriving business. In the late 1940s and 1950s, they opened the Brown Cow Drive-In that was near and dear to the hearts of local teens.

MEMORIAL TO MYRON AND ROSALIE, HOUSEL'S NURSERY AND LANDSCAPING. In 1940, Charles D. Housel and his son Myron planted 44,000 trees on their 22 acres off Lewis Avenue near Temperance. Charles, his wife Bertha, and the family came out from Toledo to picnic on weekends. By 1955, the family had moved to Temperance and their son Myron had begun managing the nursery full-time. Rosalie was an able assistant. Later their son David became the manager. His wife, Olga, now serves as secretary and sales lot director. A special tribute in 1990 from state senator Norman D. Shinkle commemorated Housel's Nursery's 50th anniversary, commending its "contributions to Michigan's economy as well as its beauty."

NATION-WIDE
SERVICE GROCERS

J. S. WHITMAN	W. J. WHITTAKER
Temperance and Samaria	Lambertville

Nation Wide Grocers Offer a Real

FLOUR SALE

AT PRICES YOU CAN AFFORD TO PAY

Town Crier, 5 lb. Sack 29c. 24 1-2 lb. Sack $1.19. Nation-Wide 5 lb sack
27c. 24 1-2 lb. sack, $1.07. Purity Pastry 5 lb 25c. 24 1-2 sack 95c.

CRACKERS Tasty Flake Sodas 2 lb. package 19c

Jar Caps, Boyd zinc, per dozen . . 25c	Fancy Peas, Nation-Wide, 2 No. 2 cans . 33c
Jar Rubbers, Finest Quality . 2 doz 9c	Fancy Corn, Nation-Wide, 2 No. 2 cans . 29c
Comet Rice, Fancy Grade package . 10c	Whitehouse Coffee, pound package . . 25c

OVALTINE The Swiss Food Drink at a New Low Price per can 31c

Del Monte Spinach, free of grit, No. 2, 13c	Northern Tissue, linenized, 3 rolls . . 19c
Lux Toilet Soap, souvenirs, 3 bars . 19c	Soap Flakes, Big 4, two 23 oz. pkgs. . 25c
Just Rite Cleanser, 4 cans for . . 15c	Magic Washer, two 27 oz. pkgs. . . . 35c

CERTO For Making Better JELLY Per Bottle 27c

Laundry Soap, white, 4 giant bars . 19c	Shinola, shoe polish, all kinds, can . . 9c
Protex Health Soap, 6 bars . . . 29c	Jet-Oil, shoe dressing, bottle . . . 13c
Clabber Girl, Baking Powder, 10 oz. . 10c	Climalene, two small packages . . . 17c

BUTTER PURE CREAMERY Nation-Wide, pound roll 32c One Pound plain print 30c

MEATS, FRUITS AND VEGETABLES

Beef Shoulder Roast lb. 15c.	Fresh Pork Sausage, lb. 21c.
Standing Rib Roast lb. 19c.	Smoked Pork Sausage. lb. 21c.
Round or Swiss Steak lb. 25c.	Potatoes, per peck 25c.
Sirloin Steak lb. 27c.	Oranges, 250s Sunkist doz. 29c.
Springer, average 2 lb. per lb. 23c.	Apples, 4 pounds 17c.
Lard, 2 lbs. 25c.	Celery, 2 stalks 9c.
Sheep Casing Wieners lb. 21c.	Cabbage, per pound 2c.
Assorted Cold Meats lb. 25c.	Dry Onions, 3 pounds 10c.

WHITMAN AND WHITTAKER GROCERY ADVERTISEMENT, 1934. Note the prices and compare to today's. Whitman was the predecessor to Francis Foods in Temperance.

MEAT PACKERS IN TEMPERANCE. Irving and William P. Hoffman moved their business from Toledo to open the Hoffmann Brothers Custom Slaughterers on Stearns Road near Jackman in 1941. After Irving died, the business was sold to Lengel Meat Packers and was enlarged considerably. This photograph shows the Lengel slaughterhouse workers in action. People who live in the area still dig up animal bones in their backyards. After 25 years in meat, Lengel decided to open the King's Cove Restaurant at this location, which was noted for its prime rib and crab legs. It was here that Mary Alice Powell judged a local italian-sausage-making contest, which resulted in a five-way tie. The building was demolished in June 1986 and replaced by the Ridgewood Plaza complex, which contained several small businesses and the secretary of state's office. Today the plaza holds the administrative offices for the Bedford Public School System.

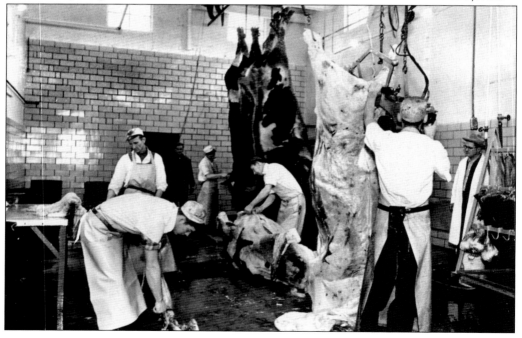

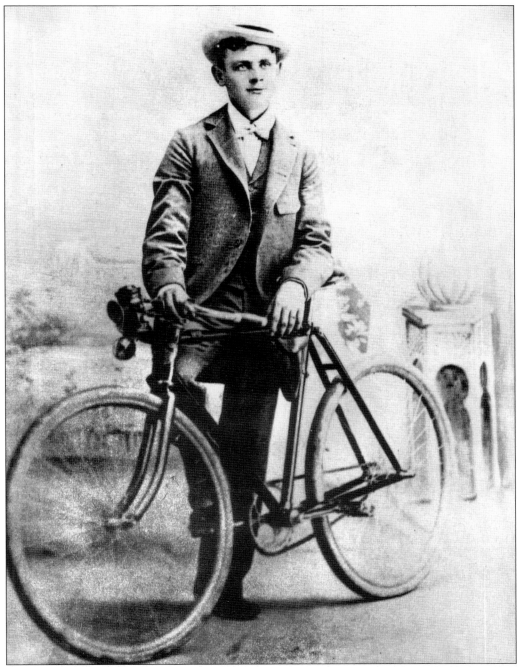

WILLIAM CANNEN, ITINERATE PHOTOGRAPHER. Cannen cycled around Bedford Township taking photographs of people, places, and events. (Courtesy of Mrs. Frances Roach [née Ansted] of Florida.)

QUETSCHKE'S FOX RANCH, CANTERBURY FOREST, LAMBERTVILLE. Up to 1,000 silver fox and mink, held in upright pens, were raised here at one time. Workers on the ranch included manager Leon Rood, whose family lived on the property, Hartsell and his brother Carl Brown, Howard Eff, and Wallace Inman. According to Leon's son Ferris, foxes are fierce and will bite if picked up. On the ranch, they were fed something similar to dog food, as well as fresh horsemeat daily. Charles Quetschke received many awards over the years for his magnificent fox pelts. When he retired from the business, Charles concentrated on his printing company and dog kennel in Toledo.

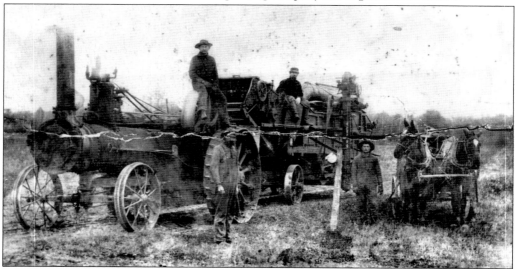

FIRST THRESHING MACHINE IN MONROE COUNTY. These machines worked constantly every fall in the Bedford farming community. William Powlesland owned one. When they were not used for harvesting grain, the steam-powered machines could be adapted to cut previously stripped logs into boards for construction.

CRARY DRUGS AND FRANCIS FOODLAND. With stores on Lewis Avenue within hailing distance for close to 50 years, both Phil Crary and Ray Francis were like old friends to their regular customers. Locals will remember the collection of oversized historic area photographs that hung on the walls of Francis's grocery store. Most of these now hang in the local history room at the library on Jackman Road.

LEO L. BOFIA (1922–1998), SUNOCO SERVICE STATION. Bofia operated the station for over 50 years. He was a member of the Bedford Township Volunteer Fire Department since 1947, holding the position of fire chief from 1961 until retirement in 1992. Leo, his wife Emma, and their children lived on Lawrence Drive in Temperance. He helped found Bedford Boys Baseball, participating until he was in his sixties. He was a member of the Temperance Rotary, the VFW Post 3925, and the American Legion Post 514. His funeral procession was lengthy and included Bedford Township fire trucks, which gave a salute to Leo with a drive past the Bedford Township Fire Station in Temperance on its way to the cemetery. Leo's son John is now fire chief of Bedford Township.

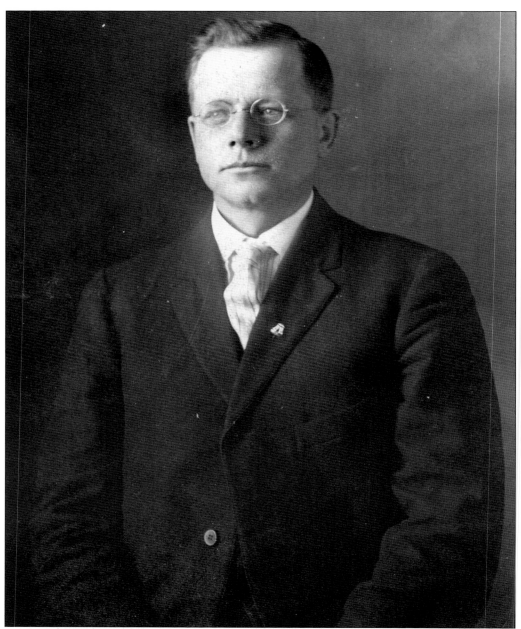

DR. OLIN E. PARMELEE. With an office in the basement of his home on Summerfield Road near Monroe Road in Lambertville, Parmelee made house calls via horse and buggy and later in his tin Lizzie. Beloved by all, he was famous for his black salve and little black pills, which cured almost anything. He delivered hundreds of babies at a price of $10 per delivery. Parmelee also loved to garden and constructed an elaborate pond system next to his home, which included miniature replicas of Higgins and Houghton Lakes. There he had a large fountain and prize-winning dahlias. Anyone who was delivered by Dr. Parmelee can join the Doc Parmelee Fan Club by submitting name, birth date, place, and memories of Doc Parmelee and/or one's own formative years in Lambertville to the author of this book.

Four

DISASTERS AND DELIGHTS

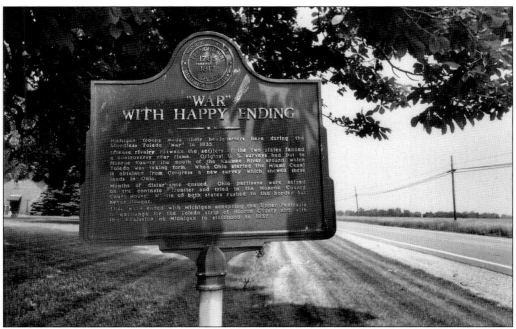

WAR WITH A HAPPY ENDING. This sign remembers the boundary line dispute between Ohio and Michigan. In a long-standing controversy since the Northwest Ordinance of 1787, both Michigan and Ohio wanted the mouth of the Maumee River for a port because it would mean great trade opportunities. In the end, it was a bloodless war, and Ohio got the port, plus around 400 acres, while Michigan was granted statehood and several thousand acres of land in the Upper Peninsula.

OFFICIALS FROM THE BEDFORD TOWNSHIP FAIR. Held from the mid- to late 1800s, the fair occurred on the Pickard-Smith property, located off of Smith Road. Since this was the highlight of the year, everyone participated in the festivities.

BEDFORD FAIR, C. 1896. These lovely ladies represent many of the pioneer families of Bedford. Pictured here, from left to right, are the following: (first row) Mary Harwick (née Smith); Euphemia Smith (née Newcombe); Ella Lowe (née Newcombe); Anna Powlesland (née Lowe), holding her baby Cecil Anderson; Emma B. Hitchcock; and Lizzie Newcombe (née Gentner); (second row) Elizabeth Kirk (née Newcombe); Lillie May (née Aysh); Mary Newcombe; and Mina Dix (née Laskey).

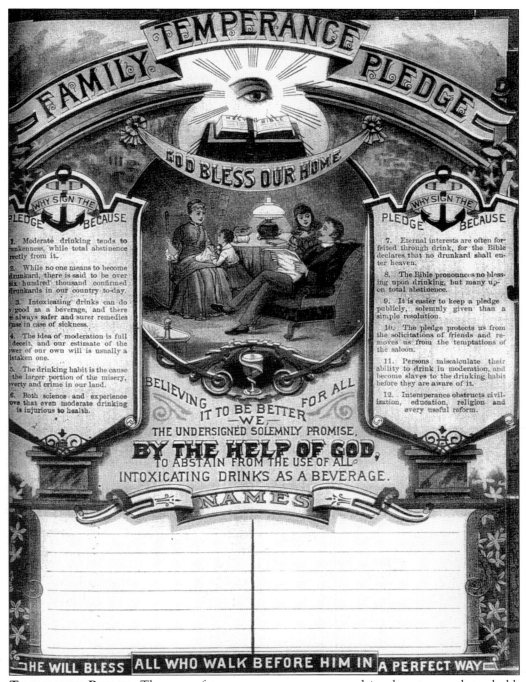

TEMPERANCE PLEDGE. The vow of temperance was encouraged in almost every household, particularly in the unincorporated village of Temperance, Michigan. It is interesting that this pledge, found in a Bible printed in 1850, was blank.

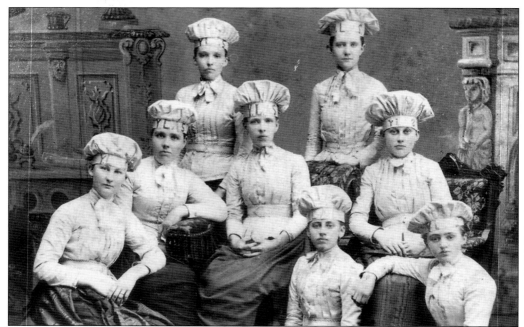

LIBERTY CORNERS LADIES AID SOCIETY PINK TEA. A Pink Tea was the society's way to introduce itself to the community and raise money to support the church at Liberty Corners. These young ladies held many fund-raisers over the years and were benefactors to several good causes in the area. This 1889 portrait depicts the charter members of the group. Shown here, from left to right, are the following: (first row) Alice Pickard (married to a Bibb), Ella Newcombe (married to a Lowe), Laura Brunt (married to a Rogers); (middle row) Grace Kelly (married to an Ansted), Lizzie Brayshaw (married to a Culver), and Minnie Pickard (married to a Hoover); (top row) Mina Laskey (married to a Dix) and Lillie Rogers (married to a Grames).

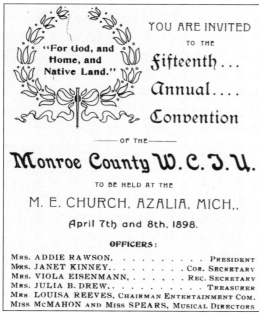

BOOKLET OF THE WOMEN'S CHRISTIAN TEMPERANCE UNION. This booklet dates to 1898; however, this organization was begun as early as the mid-1800s and still maintains members in the area today. Jane Eisenmann is treasurer for the LaSalle chapter, and her twin sister, Jean, is vice-president. The two women are co-registrars for the national organization.

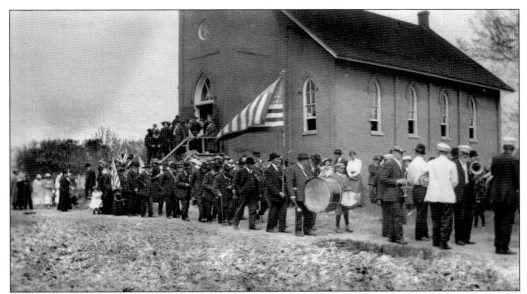

GENTLEMEN OF THE GRAND ARMY OF THE REPUBLIC. Civil War veterans join local musicians and dignitaries as they line up in preparation for Memorial Day parade ceremonies at the Lambertville Methodist Church and Cemetery. Howard Schuler served as grand master for 38 years and took photographs to record the events.

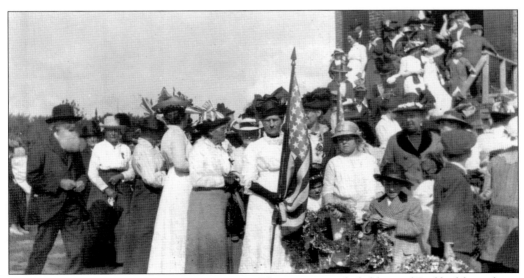

MEMORIAL DAY, LAMBERTVILLE CEMETERY. The women and children of Bedford have been hard at work making and decorating fresh evergreen wreaths. The grave of each veteran was decked with a wreath and a flag on Memorial Day to honor the service to his country.

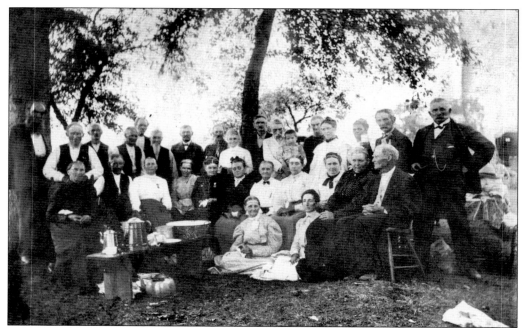

GRAND ARMY OF THE REPUBLIC MEMBERS AND FAMILIES. Enjoying a picnic at Bullock's Grove in 1913, Andrew Jackson Teal (far right) established Lawton Post No. 452 at Samaria. This group of veterans marched in the annual Memorial Day parades at the Lambertville Cemetery.

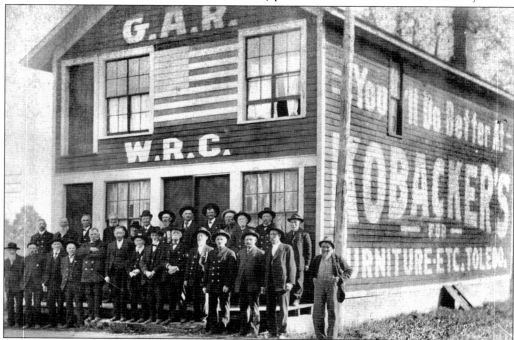

LAWTON POST 452, ESTABLISHED 1900. The Grand Army of the Republic met upstairs in Elijah Weeks's store next to the railroad tracks. The Women's Relief Corps Auxiliary met downstairs. All marched in the annual Memorial Day parades at Lambertville Cemetery.

TRAIN WRECK, BEDFORD TOWNSHIP. The Toledo, Ann Arbor, and Jackson, known locally as "The Ragweed," was a milk run that made 32 stops from Petersburgh, Michigan, to the Ohio line. It then backed up all the way to Petersburgh. Locals began hitching rides to Toledo, and before long a passenger car was added. In August 1913, due to loosened crossbeam rigging on the locomotive, the train derailed on the curve at Smith Road and Summerfield in the area called Fortuna. The engine capsized on the engineer's side, trapping Mr. Beitner and scalding him to death. Harold Smith, who lived nearby, heard the crash, rushed to the scene, and later related that the engineer screamed, pleading for someone to put him out of his anguish, and then there was silence. The fireman on the train was badly burned but recovered and continued his railroad career. (Photograph by Paquette.)

HOMECOMING PARADE, TEMPERANCE, 1918. Red Cross ladies march proudly up Lewis Avenue toward Carr Park. Records show that many women did their part by knitting hats and sweaters for servicemen, rolling bandages, and performing numerous other tasks to help the war effort. The chairman of the Samaria chapter of the Red Cross in 1917 was E. J. Harwick, and membership totaled 32. The group met in the Women's Relief Corps facilities at the Lawton Post. That year, the Samaria chapter completed 7,511 hospital and refugee garments and bandages and knitted 231 articles.

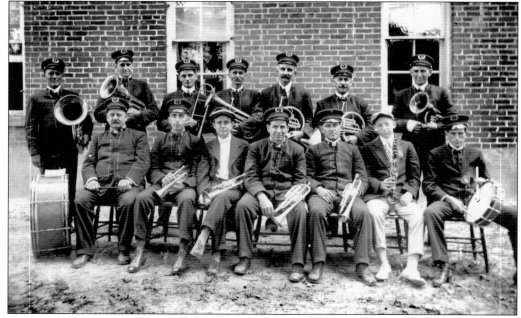

TEMPERANCE BAND MEMBERS. Taking a breather after a 1912 performance are the following, from left to right: (first row) Samuel Wallace, Roger W. Eisenmann, Roy Miller, George Adams, and Burton Blouch; (second row) Bert Dull, Upton Corl, Harry Meinhardt, St. Clair Bird, Mott Hubbell, David Dull, and George R. Kinney.

SHERIFF DULL. Sheriff Edmond Dull (1863–1910) was killed on August 5, 1910, in the line of duty, shot three times by a man he was tracking. People from all over the county were outraged, as the sheriff was very well liked and the circumstances of his death were tragic. The murderer was caught and protected from the mob, which, it was rumored, would have lynched him. There was widespread coverage in the newspapers. Dull had two funeral ceremonies: one in Monroe, where he worked, and one in Temperance, where he lived. The crowds were so large that many had to stand in the street.

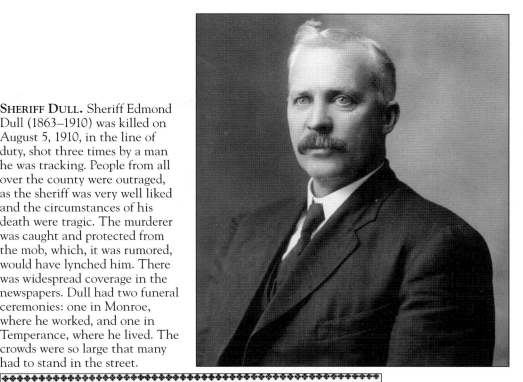

PROCLAMATION

The sudden and tragic death of the sheriff of the county, shot down in cold blood, while in the performance of his sworn duty, calls for suitable action on the part of the community of which he has been a resident, during his years of public service.

His remains will lie in state at the Sheriff's residence from noon on Thursday, August 4th, to noon of Friday August 5th. Services will be held there at one o'clock P. M., of Friday when the remains will be taken to St. Paul's M. E. Church, where public services will be held, at the conclusion of which the remains will be taken to Temperance, Michigan, for interment.

In honor to his services and the manner of his death, I most earnestly enjoin upon the citizens of this city that during the hours of the funeral services, from 12:30 to 2:30 P. M., of Friday, August 5th, that business be universally suspended, and all places of business, of whatever character, be absolutely closed during those hours and that our business men personally join in paying the last tribute to a brave and earnest officer.

Given at the Executive Office of the City of Monroe, Michigan, this third day of August, A. D. 1910.

JACOB MARTIN,
Mayor.

SUNDAY EVENING CYCLONE. On March 28, 1920, a cyclone roared through Bedford Township, leaving a swath of destruction. It took the top off the Lambertville School and destroyed the lovely oak grove where it stood. It damaged the Lambertville property of Doc Parmelee, as well as several other homes in Lambertville and Samaria. The Samaria School was leveled. No one was killed, but the destruction of two area schools was a blow to the educational system in Bedford.

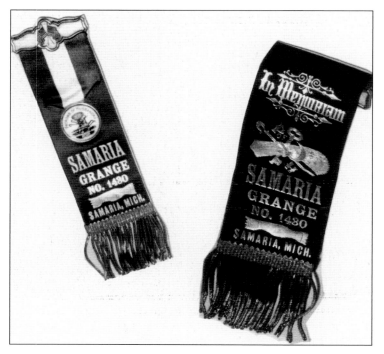

RIBBONS OF SAMARIA GRANGE NO. 1430. The Patrons of Husbandry, whose symbol is a sheaf of wheat, aided local farmers by obtaining necessities such as feed and fertilizer at discount prices for its members. The Grange Hall hosted entertainment including dances, card parties, and fund-raising chicken or oyster suppers. Albert Danzeisen was the last grange master, a position he held for 20 years. His wife, Dorothy, and Ethel Shaffer were two who earned their 50-year pins from the Grange. The building still stands.at 1430 Samaria Road.

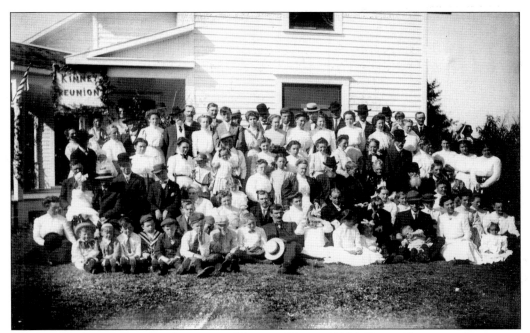

KINNEY REUNION AT THE ABRAHAM MAYBEE HOME, 2766 DEAN ROAD AT DOUGLAS, LAMBERTVILLE, 1909. Jacob Maybee married Margaret Kinney. Abraham Maybee married Kitty Hitchcock. Other family lines are Baldwin, Adams, Smith, Hartz, Butler, Elliott, Osgood, and Manley.

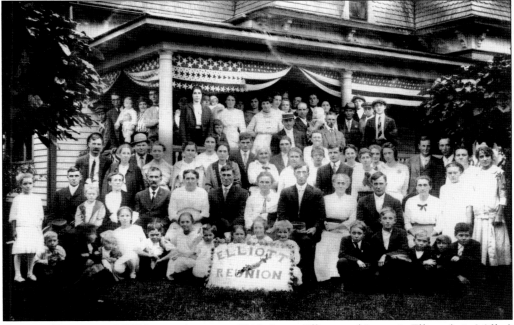

ELLIOTT REUNION, 8855 LEWIS AVENUE, 1915. James Elliott and Lucretia Elliott (née Miller) had 14 children. Some of the related families are Kinney, O'Dell, Cornprobst, Wilson, Ford, Hettler, Kline, Westerman, Spotts, and Kelly.

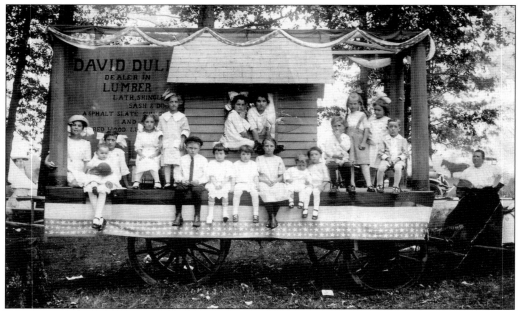

DAVID DULL'S PARADE FLOAT. Dressed in their Sunday best, the young ones are primed for their part in the Bedford homecoming parade to Carr's Grove. David Dull's lumber mill business operated in Temperance from about 1909 until 1920. However the family named Dull had actually been in the lumber business since the 1890s.

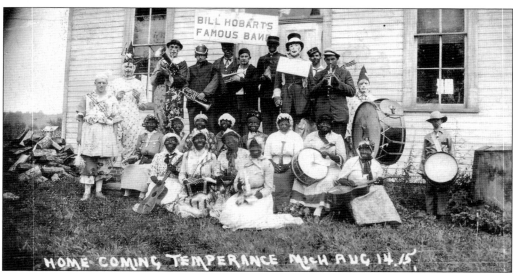

BILL HOBART'S FAMOUS BAND. Bill stands in back wearing a bow tie. This photograph was taken in front of the Temperance Town Hall on West Temperance Road for the August 14, 1915, homecoming.

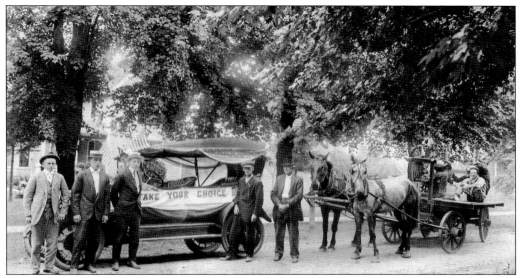

THE TEMPERANCE HOMECOMING PARADE OF 1915, AREA RESIDENTS AND THE DEMON RUM. You can "take your choice" and embrace the concept of Prohibition, be well-dressed and upstanding, and drive a fancy automobile, or you can join the miserable looking cartful of falling-down drunkards, wasting their families' fortunes on the bottle or the jug. Among the actors in this impressive scenario was Temperance mail carrier Ernest O. Bemis.

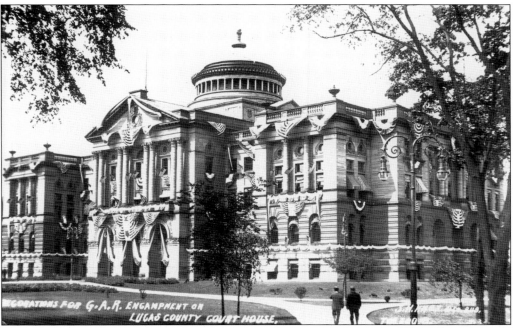

THE LUCAS COUNTY COURTHOUSE, SWAGGED IN PATRIOTIC BUNTING. The Grand Army of the Republic held an encampment in 1908 to honor those who served in the Civil War. Over 3,600 area schoolchildren participated to form a living American flag for this major celebration in downtown Toledo. A memorial postcard preserves the historic scene.

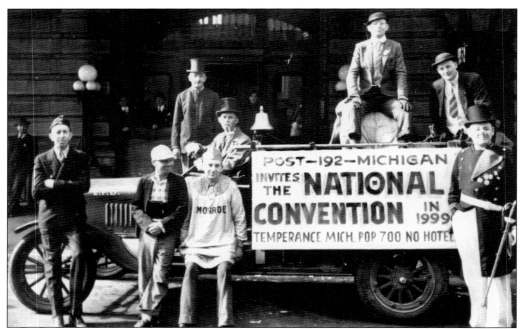

AMERICAN LEGION NATIONAL CONVENTION, 1937. Attending the jolly affair, the following participants drove the Lambertville fire truck all the way to Cleveland. Pictured here, from left to right, are John DeLo; Ernest E. Robinson, dressed as a farmer; Aubrey F. Goldsmith, in his "Forty and Eight" smock; and Charles Beam, resplendent in a general's uniform borrowed from a Commodore Perry doorman. Carl Ruckreigle sits in the driver's seat. In the chauffer's outfit is Mavor Thorn. Bill Fielding, in a constable's costume, and Leo Dohm sit in the back of the truck.

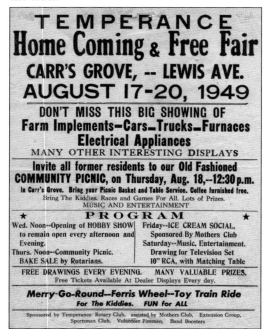

ROTARY CLUB ADVERTISEMENT. The delights offered at the Temperance Homecoming Fair of 1949 are itemized here.

LeRoy "Bud" Parmelee in the Giants Dugout. Bud was the only man from Monroe County to play major-league baseball. Born in 1907, he graduated Lambertville High School in 1925. Baseball was his game, and the six-foot-one-inch, 190-pound teenage pitcher was signed by Toledo Mud Hens coach Casey Stengel. In 1932, he married his high school sweetheart, Ortha Smith. By 1933, he had joined the majors—first for the Giants (1929–1935), the St. Louis Cardinals (1936), then the Chicago Cubs (1937). Bud made All Stars along with Ted Williams in 1939. He retired from baseball during World War II.

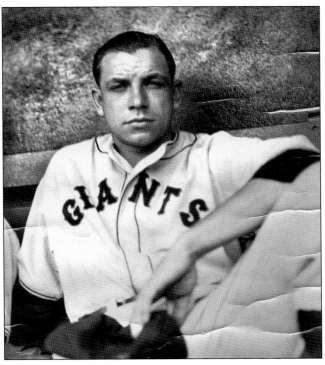

Plane Crash, Temperance. Ensign Arthur M. Paulsen, 23, a student pilot from Grosse Ile Naval Base, died in farmer Arvin Kirk's cornfield in Temperance on January 10, 1946. The engine failed and the plane exploded after a crash landing. The plane struck the only cottonwood tree in the farmer's field. Mrs. Hayward, a neighbor and a nurse, was among those who rushed to the scene and tried to help the pilot, however, nothing could be done for him. This tiny fragment of his charred silk parachute would be her only tangible reminder of the tragedy.

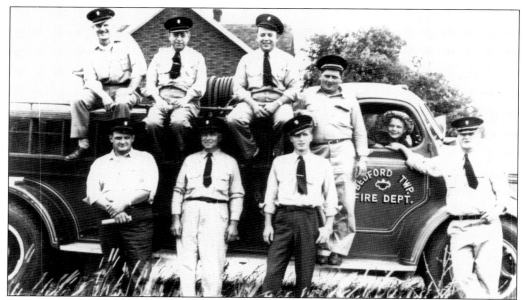

Bedford's First Fire Department Truck. This truck was received in 1945, much to the delight of the volunteer firemen of the area. Earlier when smoke and flames had been seen billowing out of the Bell family home, neighbors started the bucket brigade and began moving furniture out. The Marathon Oil Refinery's fire truck came to their aid, but the house was a total loss. Shortly after that, the first Bedford fire truck was purchased.

Odd Fellow's Hall Burns, October 22, 1948. During this fire, two pianos were saved. After that, the Temperance IOOF shared the Lambertville IOOF facilities on Summerfield Road. Lodge No. 467 and the Eva Rebekah Lodge No. 299 celebrated their 100th anniversary on May 18, 1997. Lodge No. 467 was instituted in 1897 with charter members Frank Jackman, William Dunbar, Albert Nearhood, Henry Howenstine, and George Webster. The Lambertville IOOF Hall was originally William Opdyke's store. It was moved and served the membership well until most of it burned.

PULLING UP THE RAGWEED TRACKS IN 1966. Train tracks were first laid through the Lambertville area in 1900 as a milk route for farmers who could also hitch a ride to Toledo or Petersburg, the two destination points. It was called the Ragweed because that was about all that passengers could see from the train. The tracks ran across the Smith farm, along Summerfield Road, crossed Knepper Drive, and then continued on up to Petersburg. The trainmen were kindhearted souls and often tossed red Prince Albert tobacco tins filled with candy and maybe a few coins to children along the route.

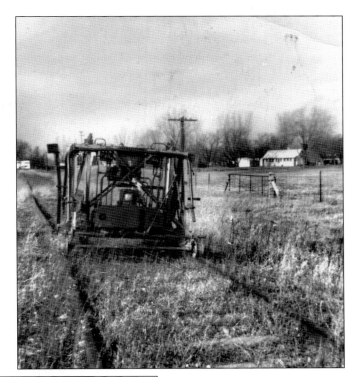

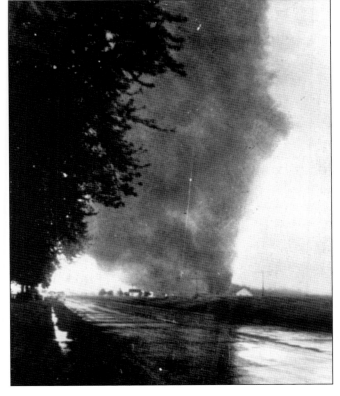

KILLER TORNADO, JUNE 8, 1953. A tornado caused extensive property damage and some loss of life when it struck Temperance and Erie, just south of Luna Pier. The centennial homestead of the Isadore Montri family on Minx Road was destroyed, along with 14 other homes and 65 farm buildings. Some 18 people were injured and 4 were killed. Remarkably the Montris saw it coming and were saved by crouching in their basement, while the twister took their home. This photograph was taken by state trooper Frank Lyon.

FESTIVAL, MAY 14, 1949. Florine Young (née Janney) staged a memorable event. Over 3,000 spectators were in attendance at the new Bedford Rural Agricultural School on Douglas Road to applaud 800 area schoolchildren involved in the production. Florine Young coordinated the event to include 200 first- and second-graders in a numbers routine, 175 in a Dutch dance, another 175 in a peasant handkerchief dance, another 75 in the Owen dance, and 200 sixth and seventh grade children dancing the Virginia Reel. Quite a spectacle!

BEDFORD SENIOR CITIZENS KITCHEN BAND, 1982. This group was organized by Myrtle Fleck (née Capaul-Murphy) from 1976 through 1982. These lively seniors played for their own amusement. As their playing improved, they were invited to perform at important events like this Lambertville Homecoming. Members included Myrtle Murphy, Cleo and Hazel Hammons, Louise Masters, Helen Glansman, Sheldon and Elda Redlinger, Dorothy and Albert Danzeisen, Bea Kloster, Paula Knoedgen, Betty White, pianist Ann Fleck, Norm Masters, Joe Kessler, Florence Smith, Barbara Halter, Helen Lewandoski, Esther Damask, and Sarah Stanley.

WAR HERO, ENSIGN HARRY LEE CORL. This World War II navy pilot was killed in action. Ensign Corl received the Navy Cross for heroism while a pilot with Torpedo Squadron 3 at the Battle of Midway. He was based on the USS *Enterprise* aircraft carrier. The son of William and Mildred Corl of Lambertville, Harry was reported missing on a mission in the South Pacific and presumed dead August 24, 1942. Posthumously awarded the Purple Heart, Ensign Corl had the destroyer escort USS *Harry L. Corl*, APD-108, named in his honor.

LAMBERTVILLE CIVIC CLUB HOMECOMING FLOAT, 1956. The civic club was organized in July 1947 with an enrollment of 140. LeRoy "Bud" Parmelee was elected president. The purpose of the organization was to promote the betterment of the community. Civic club proceeds were used for youth programs and for improvements to the athletic field at Parmelee Park. Here Cub Scout Troop 40 rides the club's float.

LION'S DEN RESALE SHOP, LEWIS AVENUE, TEMPERANCE. The principal fund-raiser for the Bedford Township Lions Club, the shop gives proceeds from its sales of used clothing to several projects in the community. Just recently, the Lions Club provided a new health van for the Retired and Senior Volunteer Program (RSVP). Staffed by volunteers, the Lion's Den is open six days a week.

MASON FAMILY REUNION, TEMPERANCE, AUGUST 1915. The son of Henry Mason and Electa Mason (née Dewey), Chester D. Mason, married Emma Jane (née Butler) and had nine children. Family descendents include Willard, Zacharias, Hayden, Bradford, Whiting, Haywood, Weeks, Stowell, Browning, and Allen. From Henry Mason's second wife, Melinda (née Brightman), came descendant families including Klinck, Tuttle, Kinney, Bolton, Burwell, and Robinson. It looks like most of these families attended the festivities.

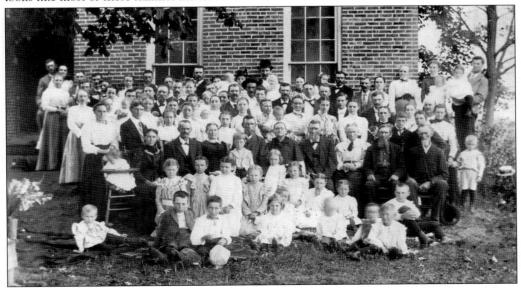

FAMILY REUNION AT THE POWLESLAND HOME ON STERNS, 1899. Looking at the faces of those in attendance, you will see many members of Bedford's pioneer families. They include, among others, Cowell, Manley, McClanathan, Jackman, Mortimore, Lowe, Aysh, Maybee, and White. Here in Bedford you only need to go back a few generations to recognize that just about everyone is related in some way or another.

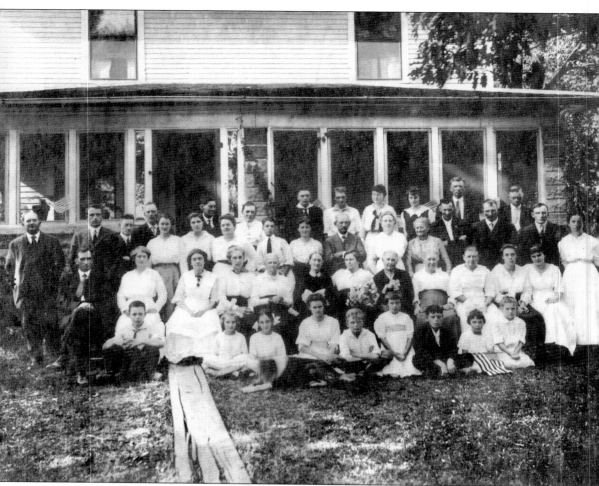

Silas Smith and Zellah Smith (née Salter) Family Reunion, 1925. Held at the couple's Samaria residence, this reunion was the last for Silas, who operated the mill in Samaria. On January 2, 1926, his truck was hit by an Ann Arbor freight train at the crossing in Samaria. Silas and his passenger, paperboy Art Douge, age 12, were both thrown. The truck was demolished and dragged under the train. Silas was found alongside the road with severe injuries, but young Douge was nowhere to be seen. A hundred yards down the track, where the train came to a stop, the frightened young paperboy was found, bruised but alive. The train had caught the strap of his canvas bag and "spread-eagled" him across the cowcatcher. His father took him home on a sled saying, "He'll be alright." Silas was taken to Flower Hospital, where he died of his injuries. He was 54 years old.

GREEN HILLS SUBDIVISION. Begun in 1956, the Green Hills development was an innovation. Builder Harlan VanDeilen decided to include a park, Olympic-sized swimming pool, and tennis courts in the subdivision. It also boasted a homeowners' organization, which planned activities for residents of all ages. The annual Steak and Champagne Party is legendary. The Green Hills Gators achieved recognition in local swim meets, and many students from this area go on to college. In the late 1960s, the *Wall Street Journal* selected Green Hills as a best place to raise children. Millie Sturtz and her husband did just that, then Millie began her own petting zoo. Millie had 45 acres and, over the next 30 years, raised chickens, guinea hens, Canadian geese, a Rhea, wolves, arctic foxes, an elk, and two buffalos. After 1990, the buffalos were replaced by 14 donkeys; only 2 of them, Dolly and Little Foot, still graze the rolling pastures. Below is a 1958 photograph of Green Hills.

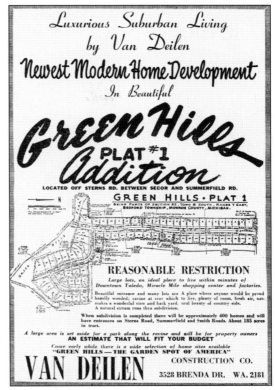

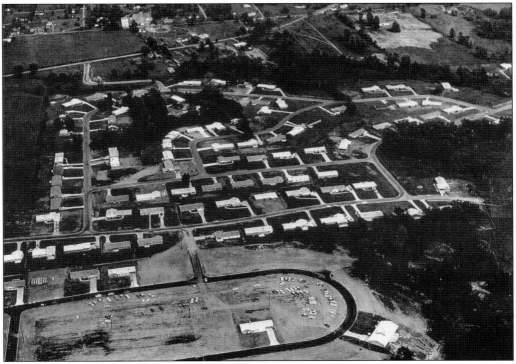

BEDFORD MOTHER'S CLUB, MARION DIENER, PRESIDENT. Formed in 1941, the Mother's Club was comprised of 125 residents who met the third Monday every month. Their projects included a scholarship fund at Bedford High School, sponsorship of Girl Scouts and Campfire Girls, and cosponsorship of the weekly Teen Town at Parmelee Park in Lambertville. The group also sponsored a blood drive, canvassed for various charitable organizations, and sponsored a Korean orphan in 1959. The organization disbanded in 1980, and treasury monies were divided between the Goodfellows, the Bedford Paramedics, and the Friends of the Bedford Library.

THE ROBERSONS, CHAMPION ARCHERS. Pete Roberson's keen interest in archery led him to introduce the sport to his wife, Cleo, and their four children. An experienced hunter with bow and arrow, Pete shot this huge black bear at Beaver Lake, Hillman, Michigan, in 1957. "Old Scarface," the bear, dressed out to a respectable 444 pounds. They ate the meat and created a rug from the hide. Cleo, who preferred targets rather than game, was Michigan State Field and Target Champion from 1953 to 1960 and National Champion in Field Archery in 1959 and 1960.

ANNUAL BEDFORD BUSINESS ASSOCIATION'S TRADE FAIR. This fair draws thousands every spring. This booth was awarded a blue ribbon for the décor provided by workers at the Retired and Senior Volunteer Program (RSVP) office in Bedford Township. Seated are volunteers Mr. and Mrs. Wood. Standing is Ellie Bergner, longtime employee at the RSVP office and the person in charge of the annual Quilt Show.

NEW BEDFORD SENIOR CITIZENS CENTER. The groundbreaking ceremony for the senior center took place at the southeast corner of Samaria Road at Jackman Road. Here director Vivian Brown (in hard hat on the right) joins forces with a few seniors to dig the first shovelful of earth to launch construction.

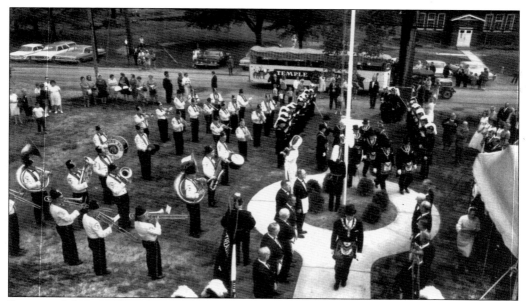

SAMARIA MASONIC LODGE 438 CELEBRATES. This grand parade in 1964, including dignitaries and a marching band, celebrated the laying of the cornerstone at the new Masonic Lodge at the northeast corner of Samaria and Jackman. Chartered in 1905, the group formerly held meetings above the old William Jackman store at Samaria Road and Walnut Street. Some charter members in 1905 were Norton H. Pardon, William H. Mason, Edward W. Hilton, Michael Whiting, Wlliam Jackman, Fred B. Doty, Elam W. Moyer, and Elijah Weeks.

CUP AND SAUCER HOUSE ROLLS TOWARD PARMELEE PARK. In 1968, the Lambertville Civic Club, Steve Tobakos, and hundreds of residents managed to save the former Methodist church parsonage and architectural treasure, the Cup and Saucer House. The organization moved it to Parmelee Park. Unfortunately, vandals burned it down. Today, Parmelee Park is the location of a wonderful skateboarding facility designed to let local youngsters work off their excess energy. The park is also an enjoyable place for hikers, picnickers, and seasonal softball games. Every June, the Lambertville Civic Club homecoming event Bedford Summerfest is a Parmelee Park happening not to be missed.

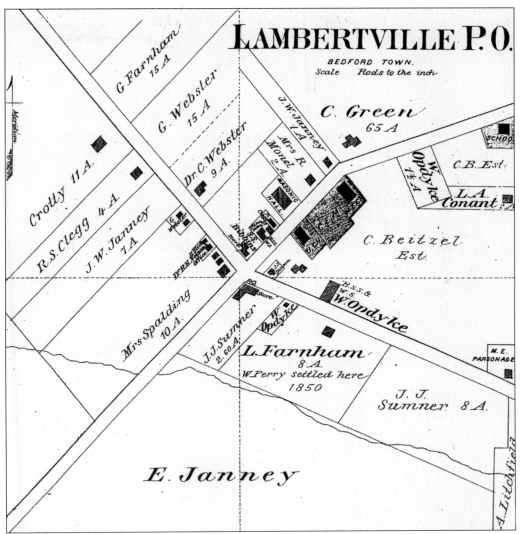

LAMBERTVILLE P.O.

BEDFORD TOWN.
Scale Rods to the inch

G. Farnham
15 A

G. Webster
15 A

J. W. Janney
1 A

C. Green
65 A

SCHOOL

W. Opdyke
1½ A

C. B. Est.

L. A. Conant

Dr. C. Webster
9 A.

Mrs R. Monet
2 A.

MASONIC HALL

C. B. EM.

C. Beitzel Est.

Crotty 11 A.

R. S. Clegg 4 A.

J. W. Janney
1 A

Store

P.O.

J. J. Sumner
2.60 A.

W. Opdyke

H. S. S. & W. S.
W. Ondyke

M. E. PARSONAGE

Mrs Spalding
10 A.

L. Farnham
8 A.
W. Perry settled here
1850

J. J. Sumner 8 A.

A. Litchfield

E. Janney

LAMBERTVILLE. This map of Lambertville, Michigan, dates to 1876 and shows the historic center of the tiny, unincorporated village.

INDEX